# THE RIVERS OF CUMBRIA

## BETH & STEVE PIPE

AMBERLEY

First published 2023

Amberley Publishing
The Hill, Stroud
Gloucestershire, GL5 4EP

www.amberley-books.com

Copyright © Beth & Steve Pipe, 2023

The right of Beth & Steve Pipe to be identified as the
Authors of this work has been asserted in accordance
with the Copyrights, Designs and Patents Act 1988.

ISBN  978 1 3981 0115 9 (print)
ISBN  978 1 3981 0116 6 (ebook)

British Library Cataloguing in Publication Data.
A catalogue record for this book is available from the
British Library.

Typesetting by SJmagic DESIGN SERVICES, India.
Printed in Great Britain.

# Contents

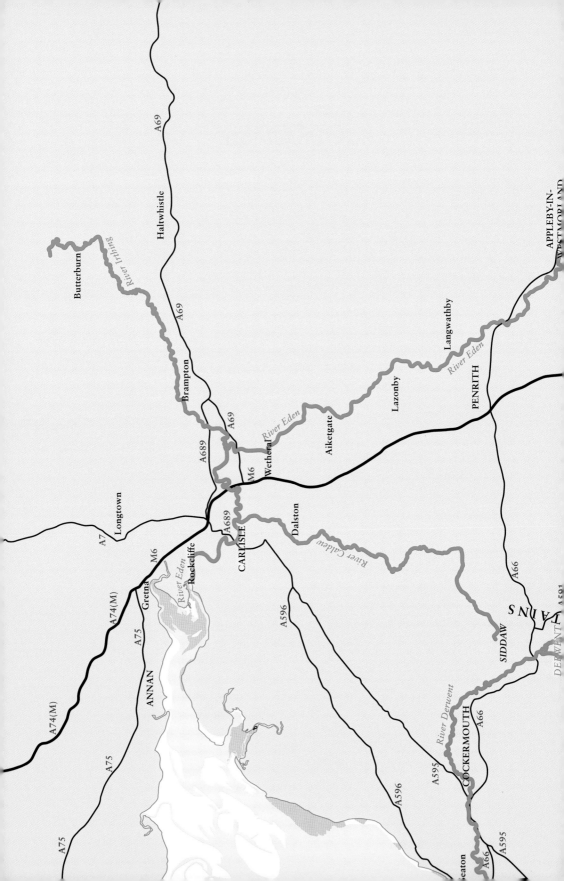

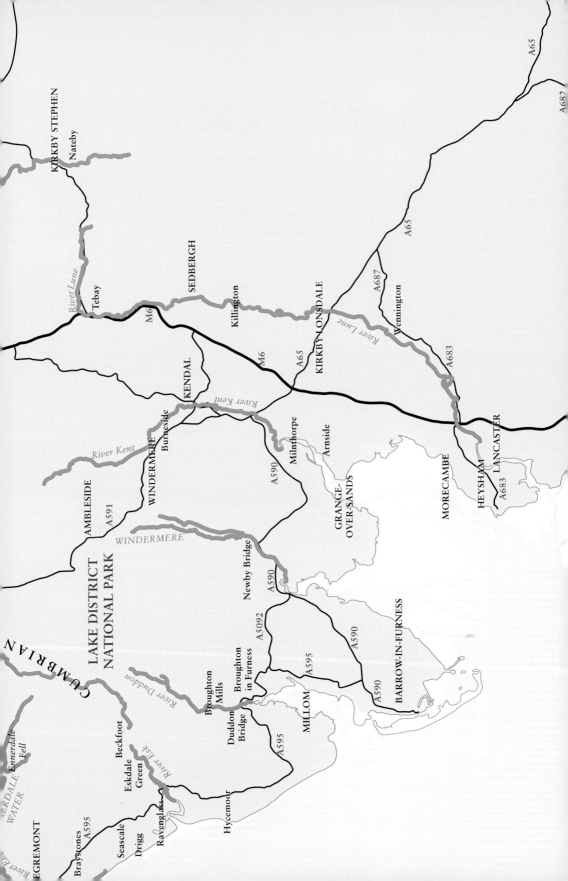

# Introduction

We'll keep this brief because this book is about the rivers of Cumbria, and not about us. We decided to write it because we have had many wonderful walks along the rivers of the county and have always been fascinated by the fact that something that is such a wonder of nature is actually at the heart of the regional industry.

In each chapter we follow the river from source to end and have selected rivers from right across the county to explore the natural, as well as the human, history. Only one, the Lune, disappears beyond the county lines and down into Lancashire, and we've included lesser-known rivers, such as the lovely Ehen, as well as the giants of the county, such as the Eden.

Each river has its own unique story and, to be honest, each river deserves its own book because there is so much to say about all of them, but we've tried to pick the more unusual stories which you may not have heard before, and we hope you enjoy following our journeys.

# 1
# River Eden

**Eden:** From the Celtic for 'water' or 'gush forth'
**Length:** 145 km (90 miles)
**Starts:** Black Fell Moss, Mallerstang
**Ends:** Solway Firth

The Bible begins with the Garden of Eden, so it only seems right to begin this book with the River Eden, although as this Eden begins with Hell perhaps it's not such a great plan after all. What becomes the River Eden starts out as Hell Gill Beck, passes under Hell Gill Bridge, and then tumbles down Hellgill Force, before hanging a sharp right and heading due north (possibly what it's most famous for), along the Mallerstang valley and on up to Carlisle and the stunning Solway Firth. To be fair, the 'Hell' in this case has a lot less to do with fiery demons and a lot more to do with the fact that this waterfall is hard to spot

Hellgill Force.

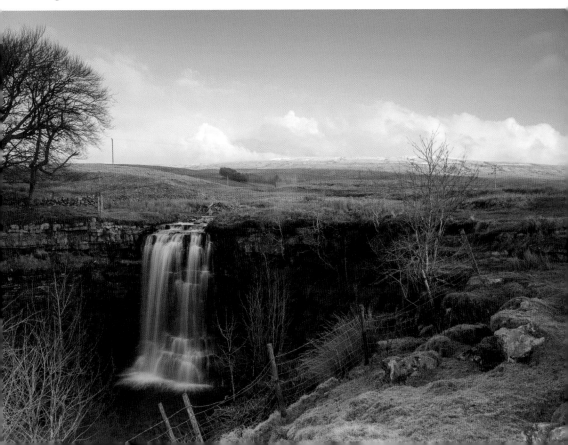

until you're right on top of it and its name is most likely derived from the ancient term meaning 'hidden'.

Its swampy origins lie high up on Black Fell Moss, at a spot appropriately called Eden Springs. It is tucked right on the border with Yorkshire, and, at Hell Gill Bridge, you can stand directly on the border between the two counties as you peer over into the deep chasm below. For the geology nerds amongst us, it's also a great place to admire the beauty of fluvial erosion – oh how I would love to get a closer look at the sides of that gorge.

At Hellgill Force the river drops from tougher sandstone down onto the more easily eroded limestone valley. The falls are well worth a visit and are most easily seen during the winter months when the leaves are off the trees.

One thing to look for along the entire length of the river are the wonderful bronze motifs from the Discover Eden project, a National Lottery-funded project that connects art with the local landscape. The motifs were designed by artist Pip Hall and each one depicts a scene of local importance. The book *An Accessible Paradise* contains a full listing and history behind all of the plaques and is definitely worth a read.

This stretch of the river is accompanied by Lady Anne's Way, a 100-mile route which runs from Skipton all the way to Penrith, named after Lady Anne Clifford a remarkable local woman.

She was born in 1590 to George Clifford, 3rd Earl of Cumberland, and counts Queen Elizabeth I as one of her earliest admirers. The family estate covered vast swathes of northern England and included five large castles. Lady Anne's brothers both died young, so according to inheritance law at that time, she should have inherited it all when her father passed away in 1605 but, instead, he left the entire estate to his brother Francis to be passed down through his family. Lady Anne, with the full support of her mother, waged a fierce legal battle, but still ultimately lost.

Following two unhappy marriages (her first husband was deemed a 'wastrel' and died young, and her second husband sided with the Parliamentarians, while Anne remained loyal to the king), Anne continued her legal fight. Her only hope was that Francis' son Henry would die without an heir, which he duly did, and in 1643 she finally gained her rightful inheritance although, thanks to the Civil War, it was another six years before she could finally return to the north and take her estate in hand.

She immediately set about restoring the family castles, including Pendragon Castle on the banks of the River Eden. The castle had been abandoned following a fire in 1541, but Lady Anne took great care to restore it in keeping with its original design. She remained in the north for the final thirty years of her life, moving from castle to castle, and was renowned as an independent lady who knew her own mind and was unafraid to follow her own path in life. She died at nearby Brougham Castle on 22 March 1676 and is buried in the family vault in St Lawrence's Church in Appleby.

Pendragon Castle isn't the only castle in the area and it's worth taking a short diversion over to Lamerside Castle (clearly marked on OS maps). It can trace its origins back to the twelfth century, was fortified as a pele tower in the fourteenth century and, although now in ruins, it's easy to make out the old room structures.

Now seems an excellent point to mention the Eden Benchmarks, another local art project, this time a series of stunning sculptures dotted along the Eden Valley from its

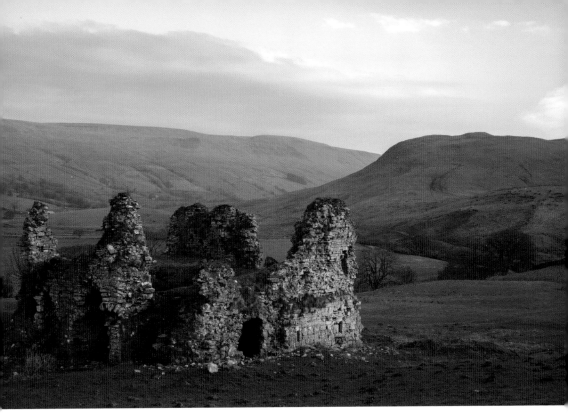

*Above*: Lamerside Castle.

*Below*: Eden Benchmarks: *Red River* by Victoria Brailsford.

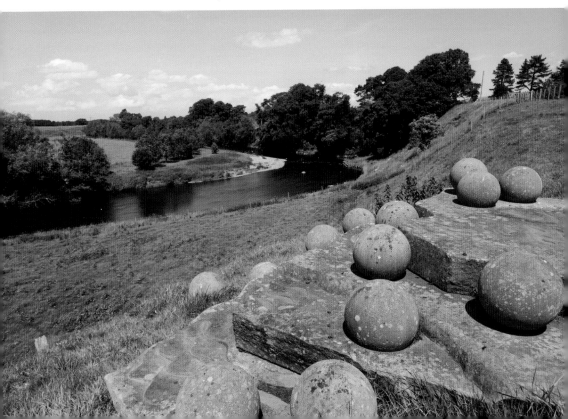

source in the Mallerstang Valley to Rockcliffe on the Solway Firth. The first of these sculptures, *Water Cut*, can be spotted alongside Lady Anne's Way, just to the south of Pendragon Castle, and it is a beautiful addition to the landscape.

The sculptures are there thanks to the East Cumbria Countryside Project who, when 1996 was declared Visual Arts Year, sourced funding to create the iconic landmarks. Each sculpture is by a different artist and each artist was given six weeks to familiarise themselves with the local landscape and people before creating their work. For the history and locations of the rest of the sculptures, check out the EdenBenchmarks.org.uk website.

The town of Kirkby Stephen can trace its origins all the way back to the Romans. Rivers have always drawn people to them, and it's why so many of the roads and railways we have today still follow river valleys. The name Cherkaby Stephen first appears in 1090 and, whilst it's generally accepted that the 'Kirk' part of the name refers to a church or place of worship, the 'Stephen' part is more of a mystery. It could be to honour the abbot of the abbey that owned the area at that time, or it could be a derivation of 'Stefan' meaning 'moor', or even simply an evolution of the original name of 'Kirk-by-the-Eden' or 'Church by the Eden'.

Continuing north from there, it's not long before you arrive at Warcop and one of the oldest, and arguably prettiest, bridges over the river. Warcop Old Bridge is small but perfectly formed, and that's not just me waxing lyrical, its design has helped it survive storms and floods since the sixteenth century, which is more than can be said about the bridge at Langwathby several miles to the north.

The original bridge at Langwathby was swept away during a storm in 1968, long before storms had names. Thanks to a gentleman making a phone call, the precise time of the original bridge's demise can be pinpointed to 5:20 a.m. on Sunday 24 March 1968. Peter Smith had just driven over the bridge, then discovered the road ahead was impassable due to flood water. He turned around, found a phone box and called Penrith the report the flooding, but the line went dead during the call as the bridge collapsed, taking the phone cable with it.

Restoring communication to the village was a priority, and a phone line was re-established, thanks to the enterprising efforts of a group of locals, a bow and arrow and some fishing line. The line was tied to an arrow and fired over the river, allowing the heavier cables to be attached and pulled across.

The bridge we see today was originally in use in Portinscale in Keswick but was no longer needed due to the by-pass being built, and so it was brought to Langwathby, where it was put into position and opened on 31 May 1968. It was only ever meant to be a temporary replacement, lasting ten years at most, but despite several attempts to build a new permanent bridge it celebrated its fiftieth birthday in 2018 and is now the longest standing temporary bridge in the country.

At Edenhall, just across the river from Langwathby, you'll find the legend of the Luck of Edenhall. Holy springs were popular because they were often the only source of clean water, and legends often spring up around them. In this case a highly decorated glass chalice was apparently found by the butler of the Musgrave family (who owned the land) when he went out to fetch water one night. He discovered it surrounded by a circle of dancing fairies who sang to him 'If e'er this glass should break or fall, Farewell the luck

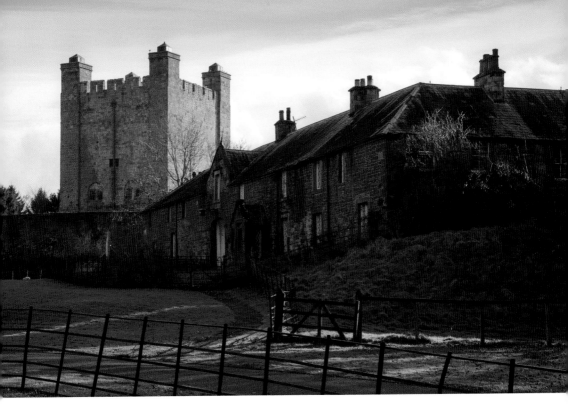

Appleby Castle.

of Edenhall'. The goblet is now in the Victoria and Albert Museum, but sadly there is no up-to-date information regarding the location of the fairies.

In between Warcop and Langwathby is Appleby-in-Westmorland. Known simply as Appleby until the boundary changes in 1974, it was granted the suffix 'in-Westmorland' as a nod to its previous status as the capital of the old county. The castle there is another of Lady Anne Clifford's masterpieces and, although she was a fierce Royalist, Oliver Cromwell (who led armies of the Parliament of England against King Charles I and was one of the signatories of his death warrant), left her alone saying, when challenged on the subject, 'Let her build what she will, she will not be hindered by me' – another mark of the respect she commanded.

The old almshouses that line the hill between the village and the cross at Boroughgate (built to commemorate the return of the monarchy in 1659), were built in the seventeenth and eighteenth centuries and include a group of houses built by Lady Anne for the widows of the parish, and which remain as homes for widows today.

Continuing its journey north, the river passes by famous local landmarks including Long Meg and Her Daughters at Little Salkeld, although few people make it over to Little Meg, a smaller stone circle around ½ km to the north-east. This is a far smaller circle and often disappears beneath the long grass in the summer, but one of the stones contains the same geometric carvings seen at Long Meg and nearby Glassonby circle – the only circles in Cumbria with these markings.

*Above*: Appleby Almshouses.

*Below*: Oglebird Scar, Temple Sowerby.

Then, of course, there are the glorious Lacy's Caves to explore, carved by Colonel Lacy's batman as a fashionable and quirky place for parties, or possibly even storing wine. They are best visited in the late afternoon in spring when the sun lights up the rocks with a spectacular red glow.

In nearby Kirkoswald, you'll find St Oswald's Church, and you'll also find the tower to St Oswald's Church 200 metres away on top of a nearby hill, most likely positioned there to ensure the bells could be heard around the parish. The church dates back to the twelfth century and near to the outside door you'll find a well, complete with a metal cup on a chain, that you can dip down into the cool, clear and wonderfully refreshing water below.

Another spot for a lovely red-brick glow is Wetheral Priory Gatehouse, a striking sixteenth-century stone gatehouse, tucked away in the tiny village of Wetheral. Pele towers are dotted around all over the county, but this one is particularly pretty, and was built as the gatehouse to the small Benedictine priory that once stood here. Thanks to Henry I the priory offered the right of sanctuary to criminals for offences committed beyond the local boundaries, with the felon being required to ring the church bell and swear before the bailiff of the manor that he would, henceforth, conduct himself in a law-abiding manner.

St Oswald's Church and tower, Kirkoswald.

Wetheral Priory Gatehouse.

If you committed a crime within the local boundaries then those rules did not apply, and you presumably had to face your crimes or try seeking sanctuary elsewhere.

Beyond Wetheral the river bears left through the wonderful city of Carlisle, a city that oozes history out of every brick and is surely one of the most fascinating cities in the country. A trip to the Tullie House Museum is essential, itself a glorious Jacobean building and home to a fantastic museum, art gallery and café.

Another couple of interesting spots to seek out are Eden Bridge Gardens located, unsurprisingly, next to Eden Bridge and, surprisingly, often referred to locally as the Chinese Gardens (for reasons that no-one can seem to explain). They were designed by Thomas Mawson & Sons and include a stunning array of plants, as well as plenty of places to sit and admire them.

Bitts Park, behind the castle, is also always worth a visit and if you take a detour into the woods directly along the riverbank, you'll find an interesting display of old bits of the Roman bridge they dug out of the river when they created the modern bridge.

And, while we're on the subject of bridges, also take a look at the War Memorial Bridge, a suspension bridge built by Redpath Brown & Co. to commemorate the lives of the soldiers lost during the First World War.

Eden Bridge Gardens.

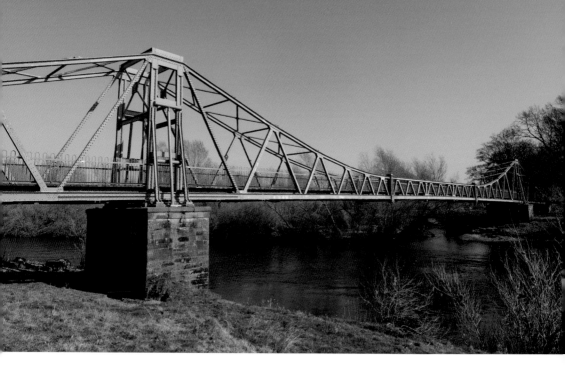

War Memorial Bridge.

The Eden then finishes its journey north, winding along sections of Hadrian's Wall and out into the Solway. On the marsh at Burgh-by-Sands stands a lonely monument to Edward I, who died of dysentery here in 1307 while on his way to battle the armies of Robert the Bruce. He lay in state in the church there before being transported back to London for burial.

The Eden may have ended, but the stunning views haven't. The Solway coast is a haven for birds and wildlife and it's a great idea to allow a little extra time to explore the local villages, as well as the wonderful Cumbria Wildlife Trust nature reserve at Drumburgh Moss.

# 2
# River Derwent

**Derwent:** From the Celtic for 'oak trees'
**Length:** 96.6 km (60 miles)
**Starts:** Sprinkling Tarn
**Ends:** Workington and the Irish Sea

The River Derwent rises amongst the highest peaks in England, travels through two of the most notable lakes in the Lake District and boasts a Professor of Adventure, one of the world's finest poets, and a gin distillery along its length. Not bad for 60 miles.

It begins its journey high up in the shadow of Great End, where the lush green fellsides are kept well supplied with rainfall, and thousands of feet pass by every year on their way to Scafell Pike. Sprinkling Tarn, the source of the River Derwent, is a popular spot to pause for well-earned sarnies and a flask of tea on the way to the summit, but it wasn't always such a well-revered spot. In the thirteenth century it was home to a branded outlaw named Bjorn (branding was quite common practice in those days) and the place

Sprinkling Tarn and Styhead Tarn.

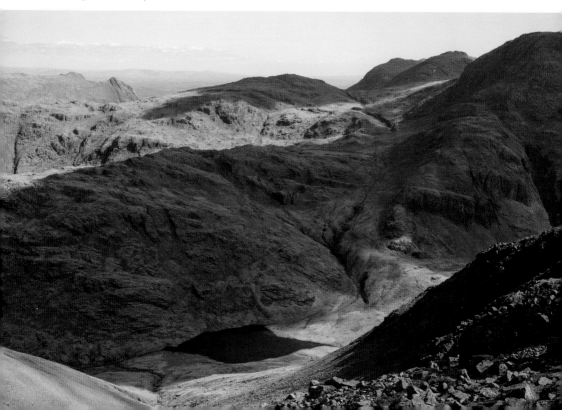

was known as Prentibiountern or 'printed Bjorn's tarn'. By the fourteenth century it was known as 'Sparkling Tarn' before taking the name we know today.

The rocks around here are strictly volcanic but also quite complex, and if you're interested in learning more about them I can certainly recommend the free iGeology app produced by the British Geological Survey. The tough, hard-to-weather rocks give us both the high peaks and the crystal-clear river water, generally considered to be one of the clearest of all of the Lake District rivers and perfect for topping up a flask on a hot sticky hike.

Although the route is very well trodden, there are still a few lesser-spotted things to see, most notably Taylorgill Force, a very pretty waterfall and easy to spot on a map, but often a detour too far for tired legs on a long hike.

Escaping the high fells, the river winds through Seathwaite (famously the wettest place in England) and out into beautiful Borrowdale, renowned for its jagged beauty. As Thomas West put it in his 1778 *Guide to the Lakes*: 'The scenes here are so sublimely terrible, the assemblage of magnificent objects so stupendously great, and the arrangement so extraordinary, as must excite the most sensible feelings of wonder, astonishment and surprise, and at once impress the mind with reverential awe and admiration.'

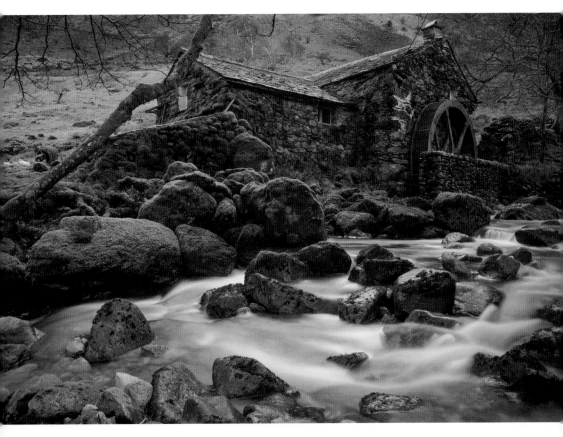

Watermill, Seathwaite.

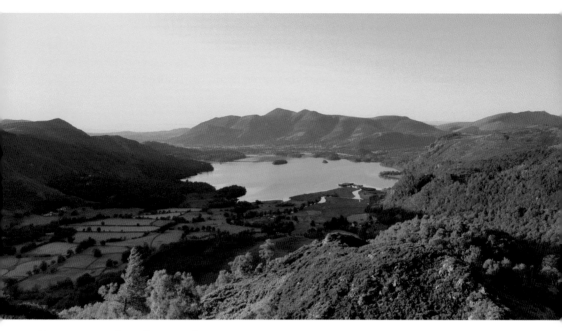

*Above*: Derwent Water from King's How.

*Below*: Castle Crag war memorial.

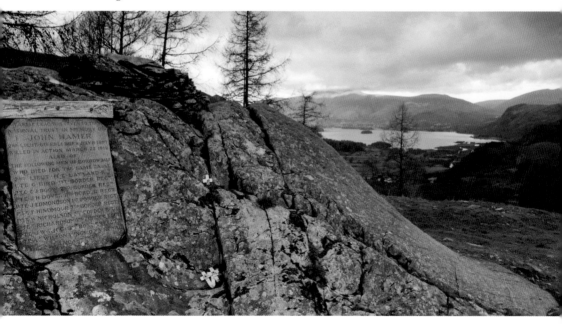

The river meanders around the foot of Castle Crag, thought to have once been the site of an ancient hill fort and, at 290 metres (951 feet), it's the lowest of all the 'Wainwright' fells. The crag was gifted to the National Trust in 1920 by Dr W. H. Hamer

as a memorial to 2nd Lieutenant John Hammer and the other men of Borrowdale who lost their lives in the First World War. Many of the men remembered there would have worked in the quarry on the flanks of the fell. Additional land around the summit was gifted to the National Trust by the widow of Dr (then Sir) Hamer following his death in 1939.

Although there is evidence of people living in the valley for many hundreds of years, perhaps the most famous resident is Millican Dalton, even though he was only resident during the summer months. Known as the 'Professor of Adventure' he was, like many of us, someone who was reluctant to grow up and conform to the corporate world.

He was born in 1867 in Nenthead, way over in the east of Cumbria (and with a wonderful old disused mine which is well worth a visit), Millican's family moved south to Essex following his father's death. Millican was only seven at the time, but a love of outdoor adventure already coursed through his veins. He took up a 'respectable' profession as an insurance clerk until, at the age of thirty-six, he could take it no longer and broke free of the corporate shackles to follow a different path in life.

During the summer months he lived in a cave in Borrowdale and guided people on adventures. He was known for his simple living and vegetarian diet, making his own bread from locally bought ingredients. He was also known for taking ladies, as well as gentlemen, on adventures, something that wasn't really 'done' at that time, and he was well known

Grange Double Bridge.

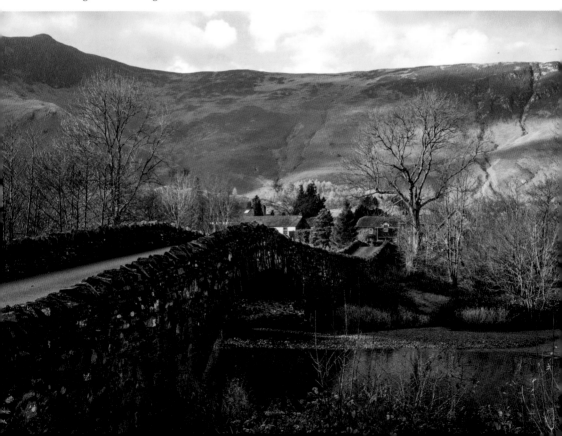

and liked locally. Millican spent well over forty years living what would now be described as an 'alternate lifestyle'. He spent his winters in the south, and it was during the winter of 1946/47 that he contracted pneumonia and passed away at the age of seventy-nine.

As the river enters Derwent Water it passes through the tiny village of Grange, with its distinctive two arched bridge. The monks of Furness Abbey built a monastic grange here, giving the place its name, and the double-arched bridge was built in 1675, long before modern traffic was a consideration. The narrow track over the bridge can, during busy periods, prove to be a bottleneck as buses, cars and campervans negotiate their way across, while hikers out for a day in the sunshine dodge in between them.

And so, to Derwent Water, which shimmers its way up to Keswick. It's one of many glacial lakes in the region, but this one is filling up fast with the sediment washing down from the surrounding fells – it's just 22 metres deep at its deepest point and reducing each year.

As it leaves the lake, the River Derwent is joined by the River Greta just to the east of Portinscale. This whole area was once one giant lake that included Bassenthwaite Lake and Derwent Water, and the area remains extremely prone to flooding after periods of heavy rain.

The first place of interest along the shores of Bassenthwaite Lake is Mirehouse, a perfectly preserved seventeenth-century English manor house. The house you see today

Bassenthwaite flooding.

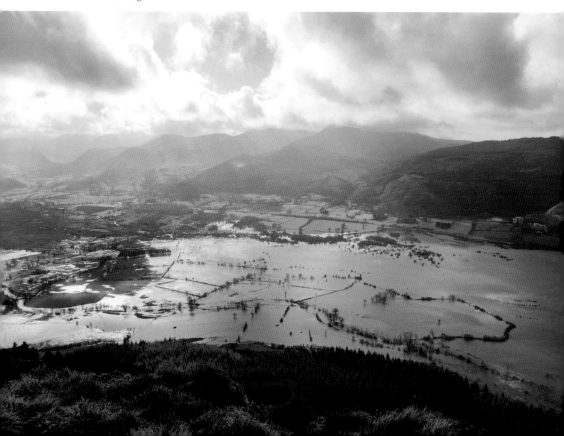

was built in 1666 by Charles Stanley, 8th Earl of Derby, and, as with any house of its age, has seen sections demolished and added over the centuries, each change adding another chapter to the story of the house. Today you can go and explore it yourself, with areas of the house open to the public, and a fantastically interesting array of original manuscripts are on display from writers such as Wordsworth, Tennyson, Bacon and Southey.

Another historical gem to look for here is the tiny Church of St Bega, just a short stroll from Mirehouse. Parts of the church date back to the tenth century and it is an absolute joy to visit, its isolated position and tranquil surroundings only adding to the beauty of the place. This tiny church has inspired everyone from Lord Tennyson to Melvin Bragg and its unique charm will make an impression on anyone who visits.

At the northern end of Bassenthwaite Lake there are several places of historical and local interest that I could tell you about, like the fabulous Lakes Distillery, lovingly restored and now producing a range of gins, whiskies, and delicious liqueurs. Or the wonderful Lake District Wildlife Park, which is not only an amazing place to visit, but also committed to protecting the animals in its care and teaching us all more about them so we can protect their wild cousins too. Plus, it just so happens to have a fabulous café that serves a Cumberland sausage in a bun for breakfast which should not be missed.

Instead of telling you more about those places, let's focus instead on Bassenthwaite Lake station, which sits on what used to be the Cockermouth, Keswick & Penrith railway line. Parts of the old railway line now lie beneath the A66, while other parts form the newly resurfaced walk in Keswick, but this little corner is a proper gem.

St Bega's Church.

After the railway line closed, the station, predictably, fell into disrepair. Alone and unloved, it became swathed in brambles and bits started to fall off. Simon and Diana Parums had watched the buildings fade and decided to step in and do something about it. Not only have they converted the old station house into a swish holiday let, they have even added a train, and not just any old train either, this one is the actual one that was used for filming the 2017 star-studded *Murder on the Orient Express*. The train is available to hire for functions, or simply to visit and enjoy a sumptuous afternoon tea as you try to figure out if you're sitting where Johnny Depp sat.

The river now swings due west to Cockermouth, where it meets the River Cocker, a fact that has resulted in the serious floods that have swept through the town over recent years. Cockermouth is famous as the birthplace for William Wordsworth and his house is open to visit and crammed with interesting stories of his life, and it was in the River Derwent that Wordsworth learned to swim. The river runs along the bottom of the garden and the Wordsworth siblings would enjoy playing in the river during the warm summer months, instilling in him the lifelong love of nature and the outdoors that shone through in his poetry.

Cockermouth was also the site of the Roman settlement Derventio which, despite being equal in importance to Carlisle and Corbridge, has far less for us to see, although there are some excellent information boards at Papcastle to fill you in on the history. The town stands at the crossroads of the Roman routes from Carlisle to Ravenglass and the road from Maryport to Keswick, and would have been vital for supporting the sections of Hadrian's Wall that run down the Solway coast.

Bassenthwaite Lake station.

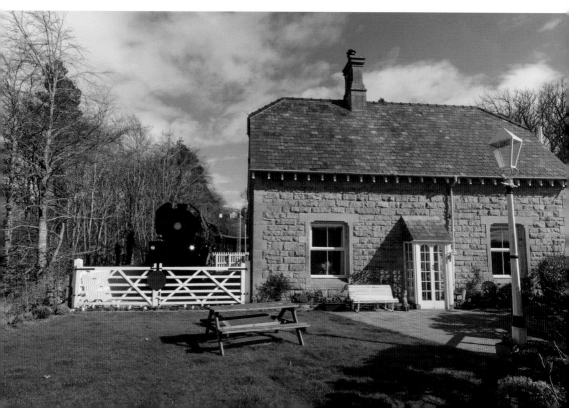

Wordsworth House, Cockermouth.

From Cockermouth it's just a short run towards Workington and the mouth of the river. The town was once an important industrial port but, it's fair to say, is a little down on its luck these days. Thanks to Sellafield, just along the coast, Workington holds the distinction of being the first town in the world to have its street lighting delivered by nuclear power.

The town also provided Mary, Queen of Scots, with shelter when she fled Scotland for the final time. There is a plaque in the harbour which commemorates her landing there at exactly 7 p.m. on Sunday 16 May 1568 – although I haven't been able to pin down how they can be so precise about the time in an era when timekeeping could be somewhat vague. From the harbour she took shelter in Workington Hall. On 18 May she spent the day in Cockermouth before being escorted to her cell in Carlisle Castle.

Workington memorial.

At the mouth of the river are two landmarks; one marks the start of one of the coast-to-coast routes, but the other is rather more curious. Up on a hill, above the harbour, you will find a 3-metre-high crucifix on top of a substantial stone base. It was built in 2014, without planning permission, by local man Peter Nelson to commemorate his late wife. He said he was in a bad place at the time and wanted to do something to remember his wife. In May 2015 the local council narrowly voted to grant retrospective planning permission following a wave of public support.

# 3
# River Kent

**Kent:** No one really knows where the name came from
**Length:** 32 km (20 miles)
**Starts:** Hall Cove
**Ends:** Morecambe Bay

Compared to some of the rivers we're covering in this book, the River Kent is tiny, but along its diminutive route it boasts spectacular fells, mills, towns, castles, mining, historical houses, one of the few tidal bores in the country, and still manages to offer a home to spawning salmon, otters, kingfishers, and a myriad of other glorious creatures.

It all begins above what is now Kentmere Reservoir, a very pleasant walk out from Kentmere village. Obviously, the reservoir is manmade, but it was made by man to compensate for other actions by man further down its course. Back in the 1840s the river was much in demand to power the mills along its route, but in an ill-advised

Source of the River Kent.

(and ultimately failed) attempt to claim more farming land, Kentmere Tarn, further down the valley, was drained. This meant that the flow to the mills became erratic, and so the reservoir was built to regulate the flow.

Unfortunately, by the time all the necessary legislation had been passed, paperwork completed, and reservoir constructed, cheap coal and railways had made their way into the county. This meant that many of the goods produced by the mills could now be shipped in more cheaply from elsewhere, so the mills steadily closed. One mill does still remain though, James Cropper's Paper Mill in Burneside, which was one of the first mills in the world to make coloured paper using synthetic dyes.

It's thought that there has been a mill on this site since the thirteenth century, and there's a record of a corn mill there in 1334 that was worth 20 shillings. Fire is an ever-present danger to a paper mill, and so it was with Croppers, which burned down in 1886, before being fully restored.

The curious shape of Kentmere Tarn is also down to man. During the failed attempt at draining the tarn for farmland, it came to light that the deposits under the tarn were a rich source of diatomite, so the next assault on this pretty spot came from a mining company, who extracted the diatomite for use in the manufacture of asbestos.

Staveley is the first town the river flows through, and there you'll spot St Margaret's Church, or at least part of it, as these days only the tower remains. The tower dates back to 1338 and, while it's hard to imagine what it was like there before there were roads and

Kentmere Reservoir.

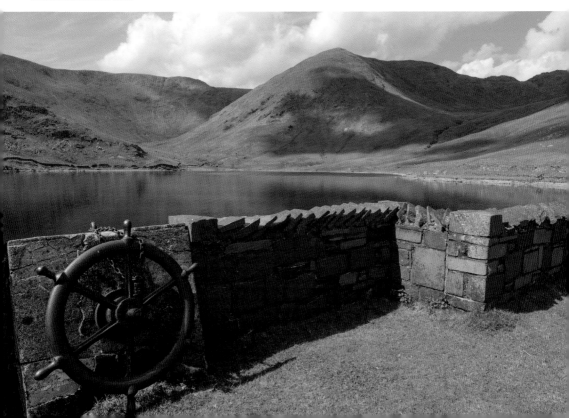

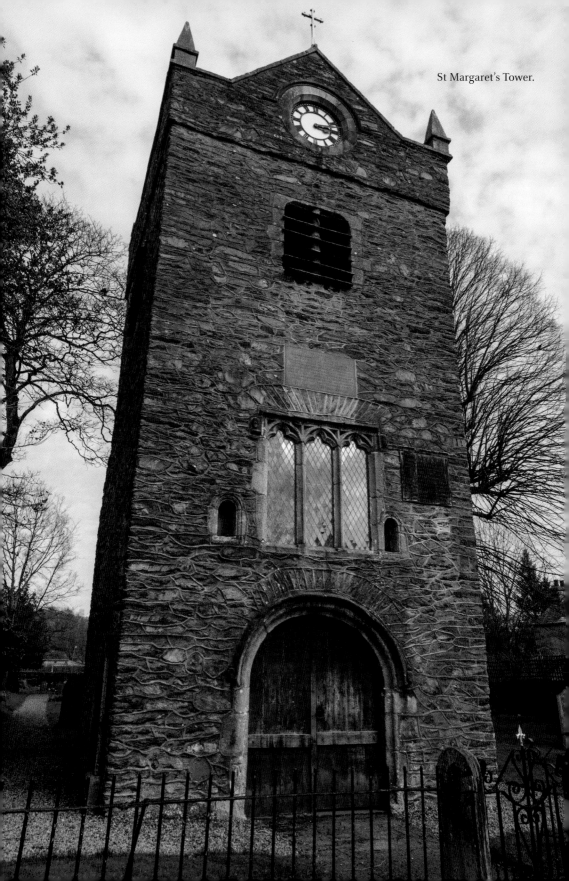

St Margaret's Tower.

houses, it's important to try, because it was the river that influenced the location of the church, not the roads, which came later.

The church was built at a spot where two river valleys met, the Kent and the Gowan, and there were fords across both rivers, allowing worshippers from both valleys to come together. St Margaret's remained as a chapel for 500 years (although for the first 300, baptisms and burials were not permitted there so locals had to travel into Kendal), and it was central to the religious and social life of the area throughout that time.

In 1665 the roads were becoming more important and, in Ogilby's *Britannia*, an early map of important coaching routes in the country, the church can clearly be seen marked by the edge of the village. By 1858 the church was in a bad state of repair, so the decision was made to build a new parish church, St James's. All that now remains of St Margaret's is the clock tower, housing a rare clock which is hand-wound by a rota of local volunteers.

And so, to Kendal, the largest town on the River Kent and the third largest town in Cumbria, after Carlisle and Barrow-in-Furness. The first road bridge the river passes beneath is officially called Victoria Bridge as its opening coincided with the golden jubilee celebrations of Queen Victoria in 1887. Better road access was needed to the central railway station, and Kendal Corporation borrowed £25,000 to build the bridge. If you ask for directions to it expect most people to look mystified, as it is far better known locally by its nickname of 'Batman Bridge', due to the ornate carvings along the top edge of the bridge resembling bats and creating a Batman-like symbol on the pavement when the sun shines through them.

Kendal is another place where the river brought in the industry and led to the growth of the town. Sheep farming has dominated the region for centuries and the Dissolution of the Monasteries in the mid-sixteenth century, together with tax changes that encouraged local cloth production, led to a boom in locally produced clothes in towns like Kendal, and wool remained the town's main industry until well into the nineteenth century.

Kendal Pattern Book is held in the town hall, and occasionally appears in local displays. It dates back to 1769 and documents rough cloth patterns produced in the town at that time. Although it is recognised as a valuable historical document, it was only saved thanks to a diligent dustman. During the Second World War Jimmy Rigg was clearing wastepaper from Castle Mills when he noticed the book and, thinking it had some local interest, he passed it to local historian Jack O'Conner, who in turn presented it to Kendal Town Hall. In 1984 it was taken to the Victoria and Albert Museum, where experts dated it to the late eighteenth century and recognised it as a unique and important book.

Previous pattern books that have been preserved were collections of fine cloths rather than the rough fabrics seen in the Kendal book, and it's thought that the book may have been taken to the market to allow farmers' wives and other workers to select the patterns for garments being ordered.

Evidence of the woollen trade in the town can be spotted along the river, where wool-washing steps can still be seen at various points. This would have been where fleeces were brought down to the river to be cleaned before being sold; if you keep your eyes open as you walk along the eastern banks of the river, you should spot a few nice examples.

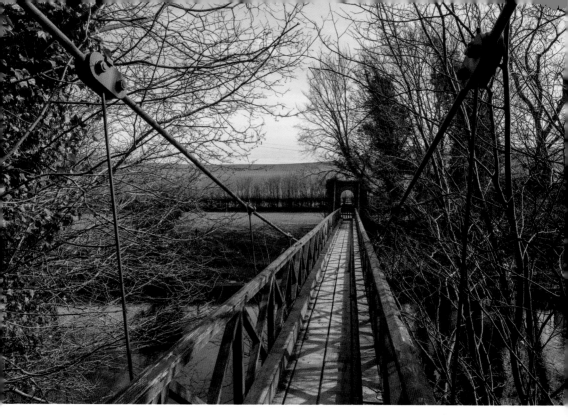

Sedgwick suspension bridge.

While you're looking at the river, keep your eyes open for otters, kingfishers and leaping salmon, as the river is home to a wide variety of wonderful species that can be spotted, even in the centre of town. 'Batman Bridge' is a good place to look for the otters; the weir just to the south of Stramongate Bridge is a great place to see leaping salmon during the autumn months; and if you take a picnic and sit on the benches in the small park along Natland Road, then there's a good chance you'll spot a kingfisher zipping past, but you may need to be patient.

The great bend in the river as it leaves Kendal forms a natural moat around the buried remains of an old Roman fort. It's hard to see from ground level but is fairly easy to pick out on Google Maps. It is thought that the fort was established on the site towards the end of the first century, although there is some evidence of earlier activity in the area. The layout of the fort, and accompanying bathhouse, has been largely determined by historic surveys, which also identified that the fort began as a turf and timber structure around AD 90 and was rebuilt in stone around AD 130. Finds in and around the site suggest that it was still being used until around AD 320, although it was likely to be mainly civilian use by then.

From here there is a very lovely riverside walk along the western bank all the way down to Sedgwick, where you will find a fabulous suspension footbridge. The original bridge on the site was built in 1859 for two reasons: firstly to provide workers at Sedgwick Gunpowder Mill with easier access across the river and, secondly, to encourage members of the public to take a detour around the site, rather than following the public footpath which, at that point, ran right through the middle of the mill – even in the days before

stringent health and safety regulations it's good to know that someone thought that a public footpath through the middle of a gunpowder mill was a bad idea. The path was officially re-routed along the eastern side of the river in 1860.

The original bridge was swept away in a flood in 1875 and the suspension bridge was built soon afterwards by Francis James Willacy who, it is rumoured, reused some of the suspension rods from a bridge in Scotland. The fact that there are no central pillars to the bridge has helped it to survive subsequent floods.

Further on down the river lies world-renowned Levens Hall, a spectacular building that evolved around an ancient pele tower. The tower has been dated to the thirteenth century and is clearly visible on a sketch of the hall from the seventeenth century. The hall has evolved over the centuries, with successive owners making their own additions, leaving us with a beautiful, but historically complex, building.

The stunning gardens were designed in 1694 by French gardener Guillaume Beaumont, who was also responsible for the gardens at Hampton Court Palace. Remarkably, the gardens have remained almost unaltered since that time, with what we see today being easily mapped against the major characteristics of the garden maps from 1730.

The beautifully manicured lawns and hedges are spectacular to see, but if you can't make it into the official gardens, then a walk around the adjoining parkland is pretty special too. If you follow the straight footpath along the eastern side of the river, just to the north of the hall itself, you will find an avenue of oak trees, which makes for an interesting walk at any time of the year but it is especially pretty during the autumn.

Sedgwick gunpowder works.

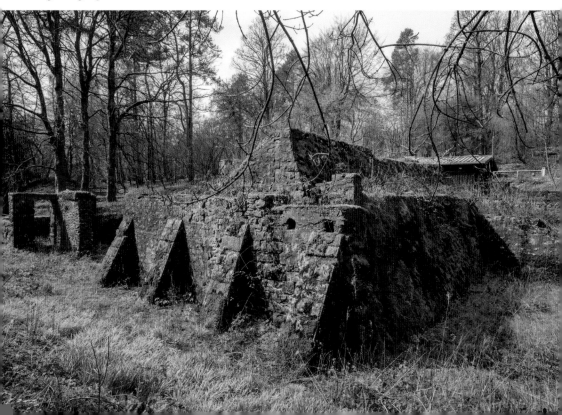

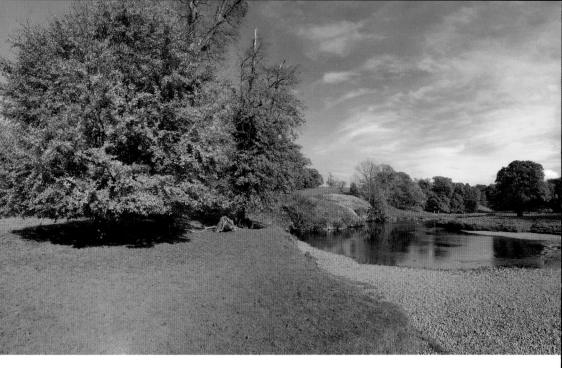

*Above*: Levens Park.

*Below*: Foulshaw Moss.

Continuing its journey towards Morecambe Bay, the Kent passes alongside Foulshaw Moss, a restored peat bog now owned and managed by Cumbria Wildlife Trust. Over the past decade they have restored this to its native beauty and, as well as being home to a huge array of rare and exciting plants and insects, it is also home to a pair of osprey who return every year to rear their young. The birds can be seen throughout the summer months hunting in the nearby lakes, as well as out over Morecambe Bay.

If you're up for a spot of exploring then take a wander around the shoreline surrounding Crag Wood, just to the south of Foulshaw Moss. Here you will find the wreck of an old 'prawner' – a type of boat that would once have been commonplace out on the bay – every year this one decays just a little more, but is still visible on aerial maps and photos of the area.

On the final stretch of its journey the river passes under the Kent viaduct, reinforced during the Second World War to allow it to carry munitions from Barrow, and out past Grange-over-Sands and into Morecambe Bay. One prominent landmark on the shore at Grange is the lido, currently derelict, but with a colourful past and, maybe, a brighter future ahead. Built in 1932, it was a saltwater lido and was hugely popular throughout its life, drawing in many visitors and lodged firmly in the hearts of locals.

Sadly, the lido closed in 1993 and has remained empty ever since. Attempts were made to demolish it, but in 2011 it was awarded Grade II listed status, protecting it from developers. At the time of writing a lively campaign is underway to save the lido and restore it to its former glory so, hopefully, a piece of local history will have life breathed back into it for future generations to enjoy.

'Prawner'.

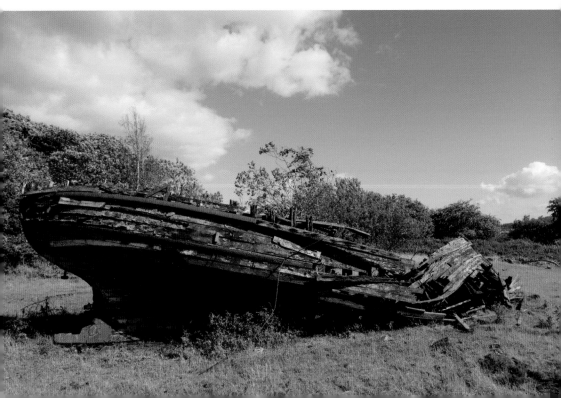

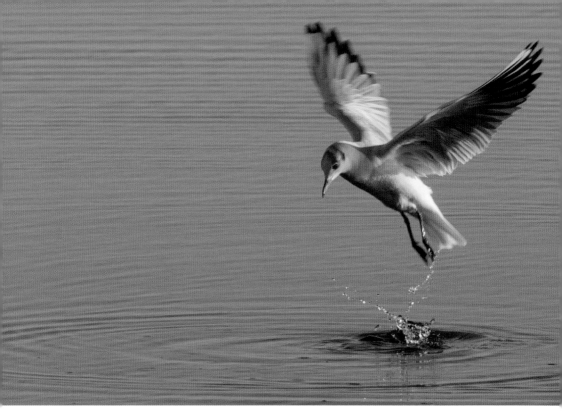

*Above*: Black-headed gull hunting in Kent.

*Below*: The end of the River Kent in Morecambe Bay.

# 4
# River Lune

**Lune:** From the Celtic for 'health giving'
**Length:** 85.6 km (53.2 miles)
**Starts:** Newbiggin-on-Lune
**Ends:** Plover Scar, Lancashire

While many of the rivers in this book require a bit of an expedition to find their source (perhaps not quite on a par with finding the source of the Nile, but still, an expedition), one reputed source of the Lune is nice and easy to find: in a small field alongside the A685, in the aptly named village of Newbiggin-on-Lune.

Of course, these things are never an exact science, and a case has been made for the source being up on the slopes of Green Bell on Ravensdale Common which, if you look at a map, probably does make a lot more sense, but St Helen's Well, at the side of a busy road, is a lot easier to find. The site is a Scheduled Ancient Monument and marks the spot where the medieval St Helen's Chapel once stood. All that now remains are the well and earthworks marking the outline of the church and the associated manor house, which were thought to be at the heart of the original village.

Or you could take a walk up Green Bell; it's a bit of a hike, but there's a clear footpath to follow and the views are excellent.

Also, alongside the A685 is a nice historic building hiding in plain sight. Most people will have whizzed past without noticing, but it's right there in full view of the road.

View from Green Bell.

The old Ravenstonedale railway station sits on raised ground on the north of the road, although maybe I should say the old Newbiggin station, as that was its name until 1877. The line opened in 1861 and closed in 1962, although the station closed ten years before then. The station was well known for the beautiful ornamental gardens behind the main building, which is now a private home.

Just before it reaches Tebay, the river passes directly beneath Raisgill Hall and an ancient cockpit dating back to the medieval era. There's not much left to see today, but enough to fill in the blanks with your imagination if you follow the public footpath which runs directly through it.

At Tebay the Lune joins Birk Beck and hangs a hard left around the site of Castle Howe, an ancient motte-and-bailey castle. Not a huge amount is known about the castle, but it is thought to have been built shortly after the Norman Conquest and, as it sits on a line from Low Borrowbridge Roman fort to the south and Brougham to the north, is thought to have been of strategic importance. Today it remains an important communications route, with both the M6 and the West Coast Mainline crossing the river at this point.

Just to the south of Tebay, at the end of a short road, you'll find a beautiful stone bridge over the river, and a small but important memorial. The memorial overlooks the railway line and marks the spot where four men died, and five were injured, by a runaway train wagon in the early hours of 15 February 2004. The wagon had faulty brakes and rolled away from where it was being unloaded, gathering momentum as it rolled downhill, before it hit the men, who had been working on the railway. Any sound the wagon may have been making would have been drowned out by the generator on site, leaving them

Old Newbiggin station house.

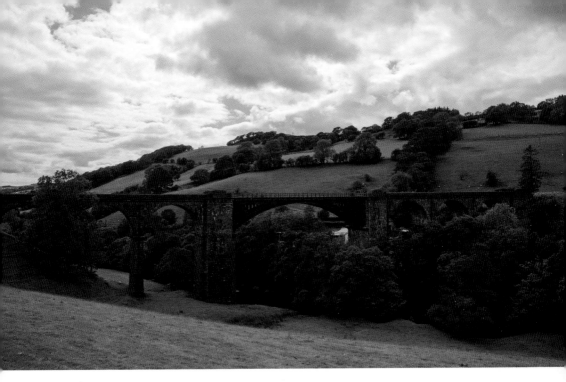

Lune Viaduct.

with zero warning. The memorial was dedicated in 2006 and the families gather each year to remember the men who were lost.

From here the river passes the site of Low Borrowbridge fort, and under a number of very pretty bridges, before reaching the hidden away gem that is the Lune Viaduct. There are plenty of footpaths that allow you to explore the viaduct from every angle, although it is not open to walk across. What makes this bridge interesting are the graceful stone arches and a cast-iron central arch, which give it a unique appearance.

It suffered from a number of accidents during its construction and once formed part of the Ingleton branch line. In its heyday it easily withstood a rolling weight of 250 tonnes, as steam-powered locomotives thundered along the line, before meeting the same fate as many small branch lines closed in the 1970s. Time, and the Cumbrian weather, took their toll, and in 2008 it underwent a major restoration, returning it to its former glory.

A much smaller, but no less significant piece of history, can be found in the grounds of Holy Ghost Church in Middleton, a few miles down the river. Tucked away in the churchyard is a Roman milestone – this isn't its original location, but it was saved and moved here in 2016 – and it is an excellent example, with the original carvings still clearly visible.

It was first discovered by accident in 1836 when a local farmer hit it with a plough. Dating back to AD 79, the original inscription reads: 'M.P. LIII – Milia Passuum 53' (most likely 53 miles to Carlisle). The farmer then added his own inscription underneath: 'SOLO ERVTVM RESTITVIT GVL MOORE AN MDCCCXXXVI' – 'Dug from the earth, restored by Giles Moore, 1836', before re-siting the stone on his land. Over the years it was knocked over by cows and neglected, before being rescued for the community by the church, who gave it pride of place in the churchyard.

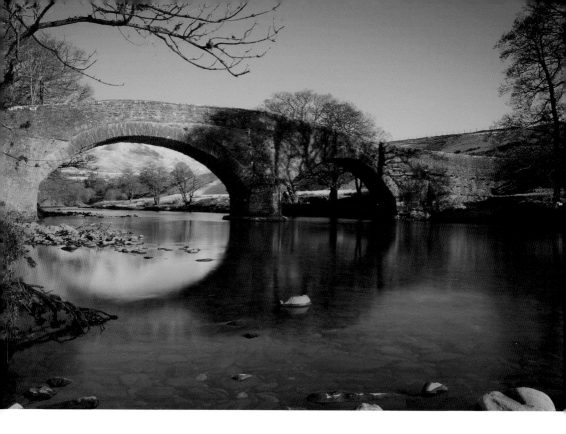

*Above*: Crook of Lune, Lowgill.

*Left*: Roman milestone, Holy Ghost Church.

Just to the south of Overton lies Kirkby Lonsdale, a town that has already been widely written about, so what else can we add? Well, away from the main town, you'll find Underley Park and Hall, which make for a very pleasant walk away from the crowds. The hall took six years to build, and the foundation stone was laid in 1825. The architect, Francis Webster, was also responsible for the Town Hall and Midland Bank in Kendal (amongst many other buildings), and the whole project cost £60,000. I'm not up to speed on local property values but feel confident that it's worth rather more than that today.

Devil's Bridge is probably what the town is best known for, and it is a lovely spot. The simple bridge spans the river and the fact that none of the main supports for the bridge sit directly in the river is probably one of the reasons that it has survived countless local floods. On Sundays it is a popular meeting spot for motorcyclists and during the summer months it attracts thousands of visitors, but historically the town has never really been quiet; it evolved from an old packhorse route and the fording place, making it a natural meeting point.

Just downstream, the village of Whittington can trace its history all the way back to the Domesday Book, where it was listed as Whitetune. In 1066 it formed part of an important manor. Its standing dwindled following the Conquest, but this tiny village was still important enough for the Scots to raid in 1322 and, in 1715 the Jacobite forces marched through and built an enclosure for their horses, which can still be identified today. The village was also the birthplace of William Sturgeon, who invented the electromagnet after teaching himself about maths and physics.

Underley Bridge, Kirkby Lonsdale.

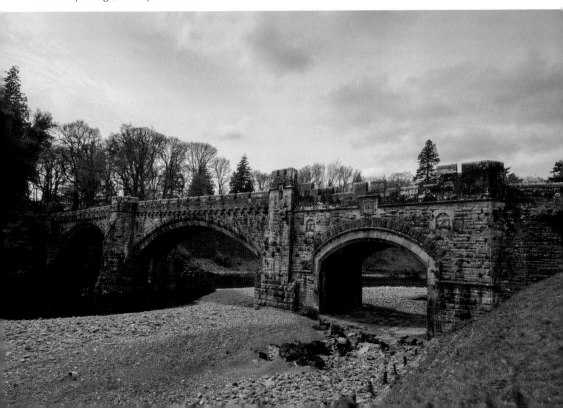

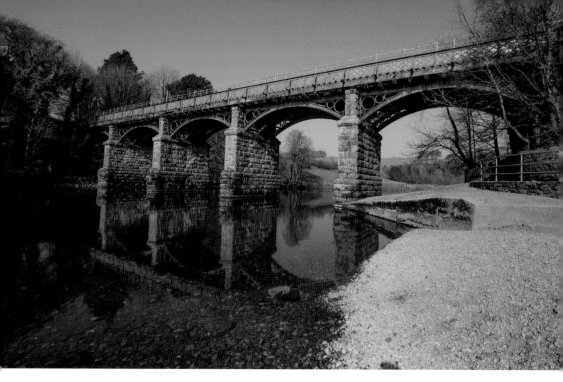

Crook O'Lune, Caton.

A little further south is the village of Arkholme, one of only a handful of 'doubly thankful' villages in England. Surprisingly, another doubly thankful village – Nether Kellet – is only a few miles away. These villages sent troops to both the First World War and the Second World War and none of them were lost. And it's not a case that they somehow got lucky by only sending one or two people. Arkholme sent fifty-nine men to the front in the First World War, all to different regiments, and they all came home again. Rather than there being a memorial to the fallen in the centre of the village, there is a limestone memorial with a Welsh slate plaque to remember everyone who served.

Before it arrives in Lancaster the river sweeps dramatically around the Crook O'Lune, which as well as being a lovely picnic spot and hive of activity for local wildlife is also the crossing point for the Thirlmere Aqueduct – a pipeline carrying water all the way from Thirlmere Reservoir in the Lake District to Manchester, and powered by nothing other than gravity. If you're ever in Manchester you can visit the fountain in Albert Square that marks the ceremonial end of the aqueduct.

On its final approach to Lancaster, the Lune Valley Ramble follows the disused Lancaster to Wenning railway line, and there are lots of wonderful information boards along the way. The old station at Halton is well worth visiting, as is the old bridge over the river. From here you can see a weir that has a 'fish pass' in the centre to allow salmon to make their way upstream.

There are a number of beautiful bridges in Lancaster, some old and some much more recent, but there's one in particular that always stands out: the Lune Aqueduct. It was built to carry the Lancaster Canal, which was, in turn, built to carry boats that struggled with the tides of the River Lune.

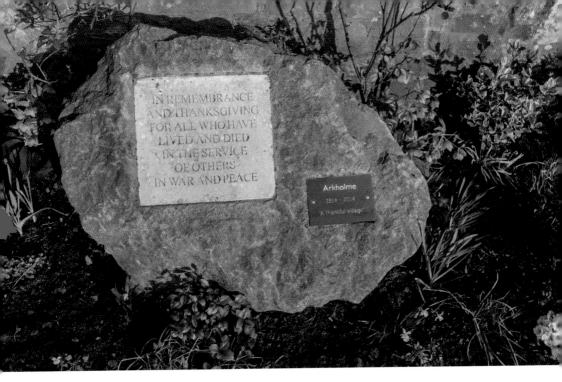

*Above*: Arkholme memorial.

*Below*: Lune Aqueduct, Lancaster.

Designed by John Rennie, it was intended to be one of a pair of aqueducts (the other being over the River Ribble in Preston), but the cost of the Lune Aqueduct spiralled so much that the one at Preston was never built. Its elegant arches sweeping across the river attracted J. M. W. Turner, who walked from Morecambe Bay to find the best spot to sit and paint it.

In the river to the north of the aqueduct is a designated Off River Spawning Unit (ORSU), part of an Environment Agency initiative to address the decline in the coarse fish population. They identified that there was an issue due to the strong currents in the river and so, in partnership with local agencies, created a protected 'off river' site to encourage wetland plants and improve spawning of fish such as dace, bream and roach.

At Sunderland Point the River Lune finally escapes out into the sea. Sunderland literally means 'separated land' and the road to the point is cut off by the sea at high tide. The point was once a busy trading port connecting Lancashire with the West Indies and the world, although, as with much of the trade at that time, it wasn't without its connections to slavery.

Sambo's Grave commemorates a young African cabin boy who died in 1736 in the nearby Ship Inn. The grave was unmarked until 1796 when Revd James Watson raised money for a headstone and composed a poem which is now inscribed in a plaque on the grave. Today the site is adorned with people remembering Sambo in their own way and is usually covered in painted pebbles and other mementoes.

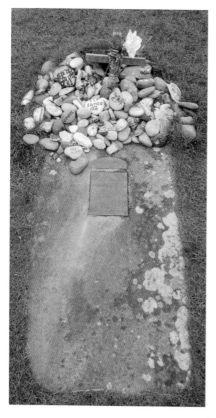

Sambo's Grave, Sunderland Point.

# 5
# River Duddon

**Duddon:** From the Celtic for 'deep' or 'dark'
**Length:** 43 km (27 miles)
**Starts:** Pike o'Blisco/Wrynose Pass
**Ends:** Duddon Sands

Oh, I am going to be in big trouble for writing about the River Duddon. The stunning river and its equally beautiful valley are generally off the busy routes, so we'll just keep it as our little secret, OK?

The river begins in an area of mild controversy, under the Pike of Blisco, or the Pike o'Blisco if you're an Alfred Wainwright fan. It has always appeared on OS maps as 'of' but Wainwright always referred to it as 'o' and, as he has many millions of fans, the 'o' version is pretty popular.

Then it passes near to what should be called 'the site formerly known as Three Shires Stone' because there used to be a stone there, then there wasn't, then there was, and now there isn't again. Or, at least, at the time of writing there isn't.

The pillar marked the boundary of the three counties which used to exist here: Cumberland, Westmorland, and Lancashire. Prior to that there were three stones set into the ground marking the counties, and Harriet Martineau in her 1855 guide to the region, suggested that 'young tourists, who happen to have long limbs, may enjoy the privilege of being in three counties at once, by setting their feet on two of the three stones, and resting their hands on the third'.

The original stone pillar marking the spot was made from limestone quarried in Cartmel in 1816. The gentleman behind the project was William Field, the local roadmaster, although the stone wasn't erected until 1860, several years after he died.

The pillar survived until 1997 when, most likely as a result of a car hitting it, it was found broken into four pieces. After a number of local groups raised the funds it was repaired by a local stone mason and re-erected in 1998, and the National Trust relocated the car park away from the stone for good measure.

Sadly, the pillar was toppled again in 2017 and although it has been taken away for repair, it is still to return, but the stones in the ground remain if you're feeling nimble.

The river follows the old Roman road down to the bridge at Cockley Beck where the modern road forks. The right fork takes you up the infamous Hardknott Pass to the remains of the Roman fort, while the left fork drops down towards Dunnerdale. The original Roman road can still be seen marked on the map, running alongside the river before swinging sharply uphill to the fort. There are plenty of public footpaths criss-crossing the river around here and it's a lovely spot for a walk as the river plunges down over a series of small waterfalls.

*Above*: Three Shires Stone.

*Below*: Sunkenkirk Stone Circle.

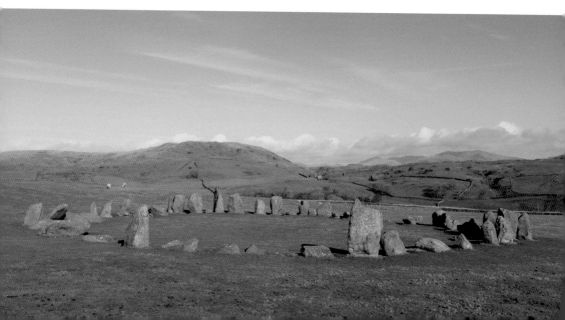

If the valley looks quiet and peaceful, don't be fooled. A fascinating and hugely detailed survey of the area was conducted and the resulting book, *Ring Cairns to Reservoirs* (R2R), contains everything you could ever have wanted to know about the ancient history of the valley. The project discovered over 3,000 stone and earth constructions, which had not previously been found, and identified that humans have been present in the valley for around 6,000 years. Of the many stone and earth constructions along the Duddon Valley, surely the finest is the Neolithic stone circle at Swinside (also known as Sunkenkirk). The circle is 28 metres in diameter, contains fifty-five still standing stones (there were originally sixty), and commands glorious views of the surrounding fells. The Sunkenkirk name arose from the legend that the Devil pulled the stones down each night when the circle was being built and, as with most stone circles, we don't really know why it was built, which really only adds to the fascination.

Whereas today the local resident population is just a few hundred, historically there would have been many more people in the valley, with activities such as bobbin making, mining, smelting, quarrying and plenty more, all taking place alongside the farming, which still continues. These industries meant that communication routes were needed to trade with the outside world, which explains many of the tracks and beautiful packhorse bridges that cross the river.

They left their mark in other ways too, with road and place names such as Bobbin Mill Hill and Cinder Hill giving clues to the past, and more obvious reminders, like the fantastic Duddon furnace. The eighteenth-century remains of the furnace are largely intact and stand over 29 feet tall. The furnace was powered by water from the river and the remains, near Broughton-in-Furness, are well worth a visit for industrial history nerds.

Our medieval ancestors left their calling card in places such as Pike Side farm where, it is believed, the barn stands on the site of a medieval long house, and it is likely that there were several other structures associated with this site. The R2R project found evidence of additional medieval outbuildings and, even using a basic tool such as the aerial photos on Google Maps, many interesting shapes can be spotted in the surrounding fields.

The Duddon Valley was also much loved by William Wordsworth, who wrote a series of sonnets about the river – an act that baffled reviewers of the day, who wondered why he was writing about an 'insignificant river' when he could have been writing about the River Thames. Once you've visited Dunnerdale, you'll completely understand.

Wordsworth first visited the river as a boy, on a fishing trip with a family friend, which didn't go entirely to plan: '...the rain pouring torrents, and long before we got home I was worn out with fatigue; and, if the good man had not carried me on his back, I must have lain down under the best shelter I could find. Little did I think then it would be my lot to celebrate, in a strain of love and admiration, the stream which for many years I never thought of without recollections of disappointment and distress.' Luckily, he returned to stay with family in Broughton during his college years, and his love of the river was rekindled.

As well as the sonnets, Wordsworth also wrote *Memoir of the Rev. Robert Walker*, a biography of a well-known local vicar. Revd Walker was born in 1710 and was the curate of Seathwaite until his death in 1802. It's not believed that Wordsworth met him, but he was certainly inspired by him. The reverend received only a small stipend of £5 per year

for his ecclesiastical duties, which was not even close to being enough to allow him to provide for his ten children. So, he supplemented his income by working as a teacher, a scribe (for those who couldn't write), a spinner of flax, and, most interestingly, as a beer seller (although he did insist on 'no late hours, no tippling, no immorality or indecency of any kind').

When he died, Revd Walker left over £2,000 in his will and was known as the 'Wonderful Walker' for his many good deeds and devoted life.

If you're after an interesting walk along the river that isn't too challenging, then there's a rather lovely loop from Ulpha to Beckfoot. The walk along the road isn't as tricky as it sounds as the grass verges are wide enough to walk along for the most part, and the bridge at Beckfoot is a lovely vantage point from which to admire the river. If you're lucky you may also spot the local mountain rescue team who use the area for their rapid water rescue training.

Not far from Beckfoot, but sadly not accessible to the public, is Duddon Hall. The original house dates back to 1805, when it was originally called Duddon Grove, but its most striking feature, a temple, was added many years later. It is thought to have been built in memory of Revd William Millers, the father of the then owner, Miss Frances Esther Millers. Miss Millers did not marry and dedicated herself to good works, and to looking after her parents; her mother died in 1828 and her father in 1843. The temple date stone reads 1843, although the temple wasn't complete until several years later, and the

Duddon Hall.

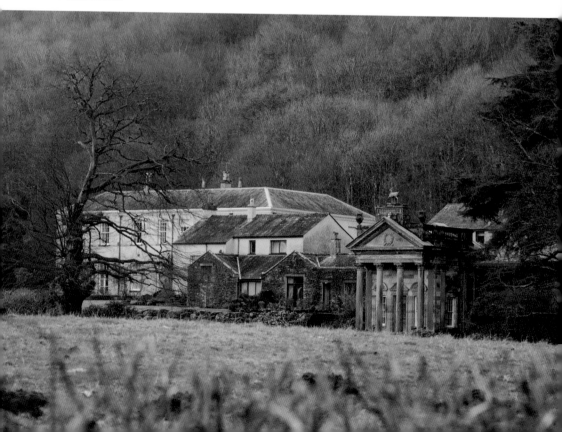

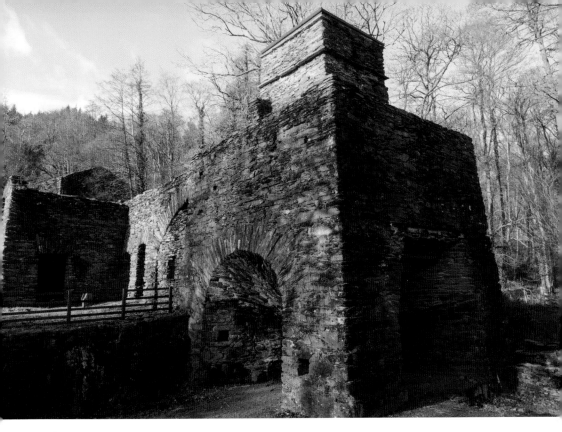

Duddon Furnace.

Corinthian pillars made this unusual building a much-admired landmark for passengers on the Whitehaven and Furness railway.

After the Second World War the house was unoccupied and, inevitably, began to suffer as a consequence of neglect. After passing through several sets of hands, a new owner took possession in 2000 and began a plan to restore the temple, with the addition of a contemporary extension. Naturally this wasn't popular with everyone and only narrowly passed the vote for planning permission, but the renovation went on to win a number of prestigious awards.

Another tucked-away gem, although this time it's one you *can* spot from a public footpath, is Broughton Tower. Broughton is just to the east of the river and a short circular walk from the village will take in both a stretch of the old railway line, and magnificent views of the tower.

The tower at the heart of Broughton Tower is an old fourteenth-century pele tower. Following a turbulent history, culminating in the execution of the 7th Earl of Derby (the owner at the time) for his allegiance to Charles II, the tower passed into the hands of the Sawrey family, who owned it through until 1920. To say they extended it doesn't do it justice, as they turned the tower into a magnificent manor house, and probably with far fewer planning issues than the owners of Duddon Hall faced.

From the 1950s through to the 1970s it operated as a convalescent home for children, and today it has been converted into private flats.

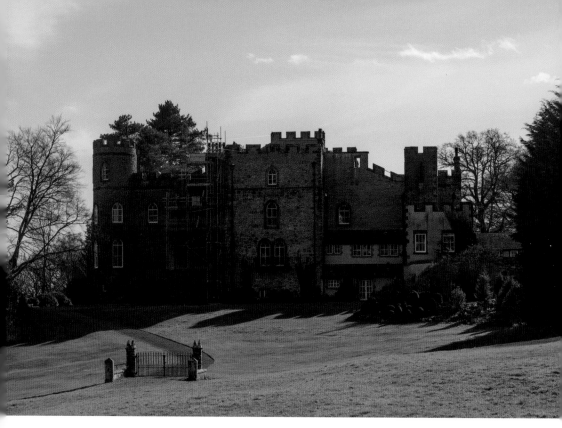

Broughton Hall.

The river makes its way out onto Duddon sands (a quick look at an OS map will show a number of old footpaths crossing the estuary) and these should only ever be attempted with an appropriate guide as the sands, and the tides, can be treacherous and catch people out every year.

Further down the estuary is Askham Pier, a fantastic spot to explore if you like your history 'as it comes' rather than shrink-wrapped and nicely packaged with a tearoom. The pier is made from the slag that was produced by the many iron furnaces in the area, and although it won't win any awards for its looks, it's robust and offers an excellent vantage point for admiring the estuary and watching the local wildlife.

The town was once the site of the second-largest iron ore deposit in the country and over 7 million tonnes of ore was extracted, with the mines and furnaces drawing in men from all over the country and changing the face of the entire region. It was these mines and factories that led to the building of the railway that still runs all around the Cumbrian coast – it's a wonderful way to admire the local coastline and you can hop on at nearby Foxfield, although as it's a request stop you'll need to flag the train down when you see it approaching.

Tucked under the shadow of Black Combe on the north side of the estuary is Millom, a town that can trace its ancestry all the way back to the Domesday Book. Although at first glance it appears to be a little down on its luck, the town has a number of lovely historic gems to discover, plus the magnificent Hodbarrow Nature Reserve to explore.

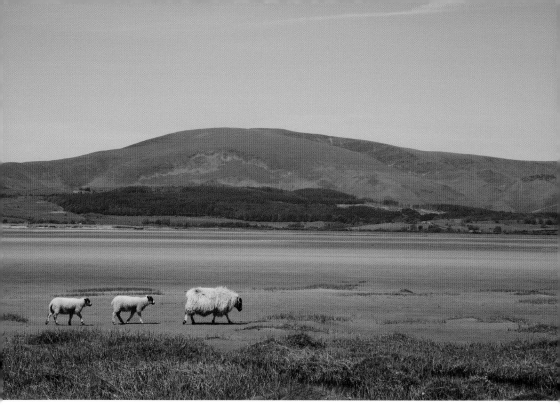

*Above*: Duddon Sands and Black Combe.

*Below*: Hodbarrow Nature Reserve.

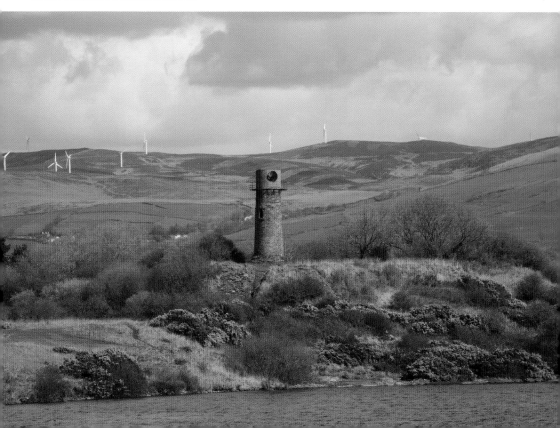

Like Askham, it was the site of huge amounts of iron ore extraction, and the huge sea wall was built to protect the mines from the notorious local tides, and the remains of the old quarries and original lighthouses are still there to admire.

And don't leave the town without a visit to Holy Trinity Church and Millom Castle. The castle (not to be confused with *Millom Castle* the schooner, which was built in Ulverston in 1870, led an eventful life, and the remains of which can now be found rotting in Poldrissick quay in Cornwall) was built by Godard de Boyvil, who held the first lordship of the manor of Millom – a position so powerful that even the county sheriff could not enter the castle without his permission.

And if you like your churches, then don't miss the splendid Norman Holy Trinity Church next door, which has many wonderful stained-glass windows to admire and a stone near to the north door that was once the base of the old market cross, erected when the town was granted a charter to hold a market every Wednesday.

The dunes at Haverigg mark the very end of the River Duddon and are one of Cumbria's finest hidden gems – not just the dunes themselves, but the impressive *Escape to Light* sculpture, built near to the Inland Rescue station to commemorate inshore rescue lifeboat crews in the UK. It was created by world-renowned sculpturer Josefina de Vasconcellos, who was well into her eighties but was still to be found, clad in her dungarees and wielding her chisel, carving the 8-tonne limestone rock into the stunning sculpture we see today. It was originally placed in the grounds of Rydal Hall but was moved to Haverigg in 2003.

Holy Trinity Church, Millom.

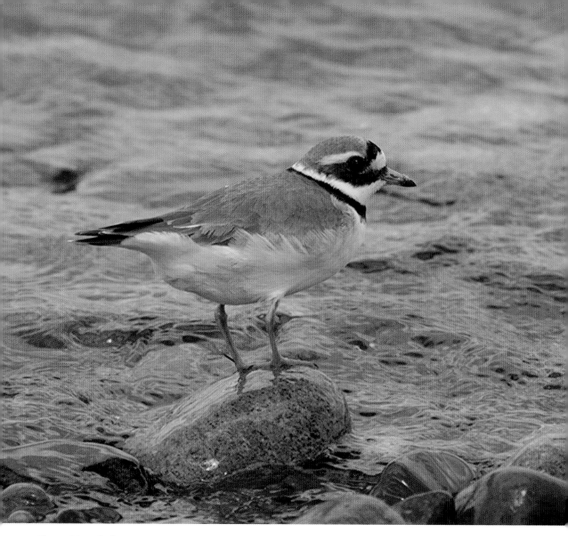

*Above*: Ringed plover.

*Below*: *Escape to Light* sculpture.

# 6
# Rivers Rothay and Leven

## Rothy

**Rothay:** From the Old Norse for 'loud river'
**Length:** 13.3 km (8.3 miles)
**Starts:** Rough Crag (above Dunmail Raise)
**Ends:** River Brathay

In this chapter you get two for the price of one as we cover two rivers that, between them, flow from the heart of the national park, through the longest lake in England, and out into Morecambe Bay.

River number one, the Rothay, starts life up under Rough Crag, just to the left of the A591 as it approaches Dunmail Raise. If you're looking for a walk off the beaten track and in the heart of the county, then this is a good one to try, with a clear track from Ghyll Foot all the way up to Greenburn Bottom.

Somewhat less off the beaten track is the iconic Lake District village of Grasmere, famed for its gingerbread and connections with Dorothy and William Wordsworth. These days the village and the tarn have the same name, but it wasn't always that way. Grasmere the village comes from Ceresmere, meaning 'lake with reeds growing around it', while the tarn name comes from Grysemere, meaning 'lake where pigs graze'. Over the years both names evolved to the same word.

Just outside the village is Dove Cottage, where the Wordsworths lived from 1799 until they moved just down the road to Rydal Hall in 1808. The house and garden are open to the public and the garden have been carefully restored to the semi-wild state that the Wordsworths favoured. Wordsworth described the place as 'the loveliest spot that man hath found' and he found much inspiration in his surroundings.

Next door to Dove Cottage is the Jerwood Centre, which is home to over 90 per cent of Wordsworth's original manuscripts and all of Dorothy's famed handwritten journals. They house an enormous collection of Wordsworth works, as well as an internationally renowned collection of significant works by other writers of the period. Throughout the year there are a range of imaginative and interactive exhibitions suitable for the whole family, exploring different aspects of their lives, so there is always something interesting to do there.

Although many thousands of people visit Dove Cottage, and the Wordsworth graves at St Oswald's Church, very few spot the water trough dedicated to Wordsworth right next to the small white roundabout on the A591 as you enter the village. For all the many hundreds of times we have driven past it, we've never yet seen anyone paying it any attention, and it really is rather lovely. It was built in the 1980s and is dedicated to Wordsworth with the inscription 'Blessings be with them and eternal praise / Who gave

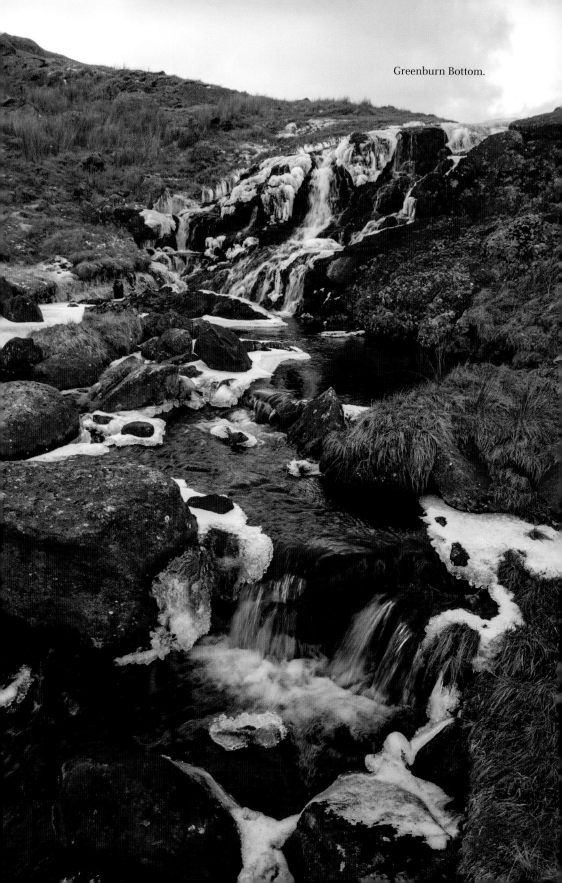

Greenburn Bottom.

us nobler loves and nobler cares / The Poets'. It's not the most dramatic Lake District memorial, but it's at least worth a look.

William and Dorothy are buried in the grounds of St Oswald's Church in the centre of the village, and there has been a church on, or near, this site since the first century. The outside of the church is austere and has even been described as ugly by some writers, but it's more that it has a no-nonsense medieval charm – it's not one to visit if you like a nice, elegant, soaring spire.

St Oswald, King of Northumberland, founded the church in AD 642 when he chopped down a sacred oak and built a church from it. Obviously that church is long gone, but parts of the church we see today dates back to 1250. At that time the church was two separate buildings, and it remained that way until 1562 when local landowner John Benson left the money in his will for the buildings to be joined. The resulting building work left a 'tangle of timbers', giving the interior a unique feel.

The other notable feature is the rush-covered floor, and the traditional rushbearing ceremony takes place in the village every year on St Oswald's day (5 August). The ceremony dates back to the 1840s and the original purpose of the rushes was to keep the air in the church fragrant. At that time the church floor was still just earth, which the local dignitaries were buried under, and probably not quite as far under as we bury people today, hence the need for the rushes. Rushes were needed all year round, but in 1841 the church floor was paved, removing the need for the rushes to be there, so the ceremony was created to maintain the links with the past.

Grasmere Gingerbread Shop.

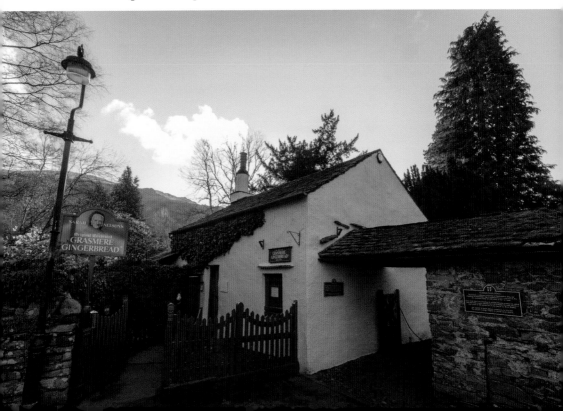

Nestled in next to the church is the world-famous Grasmere Gingerbread shop, a tiny cottage that always has a big queue outside it. The shop was founded by Sarah Nelson in 1854 when she began selling her delicious homemade gingerbread from a tree stump outside her front door. With the region having been popularised by poets such as Wordsworth, tourists were now flocking to Grasmere and it wasn't long before Sarah's gingerbread found fame around the country, and the sticky, gooey, half-biscuit/half-cake wax-wrapped slab of loveliness firmly became a 'must see and eat' for all visitors. The recipe remains a closely guarded secret and is unchanged to this day.

From Grasmere the Rothay winds its way down through Grasmere (the lake) and Rydal Water, both very popular with swimmers and walkers alike, before looping round under the shadow of Rydal Hall. In the grounds of the hall, you will find The Grot (short for grotto), built in 1668 by Sir David Fleming specifically to sit in to admire Rydal Falls, and one of Wordsworth's favourite spots when he lived in the hall.

As it weaves through Ambleside and approaches Windermere, the Rothay joins forces with the River Brathay next to the remains of the Roman fort – an indication that this has been a strategically important spot for a very long time. Although considered to be rural these days, like many lovely Lake District locations, Ambleside has an industrial past. In this case it was the production of charcoal for the smelting furnaces of Barrow and West Cumbria and industrial-scale timber production for the many bobbin mills in the region.

The famous Bridge House landmark in the town was once a folly in the grounds of Ambleside Hall – what was once the hall itself is now the Golden Rule pub a couple of streets away. Although much has been written about the late nineteenth-century tourist boom brought about by a combination of the expanding rail network and the popularisation of the region by the romantic poets, places like Ambleside took a while to catch up with 'modern' standards of living.

Harriet Martineau, travel writer and early feminist, lived in the village and surveyed the local population. She found standards of nutrition and sanitation were far short

Grasmere.

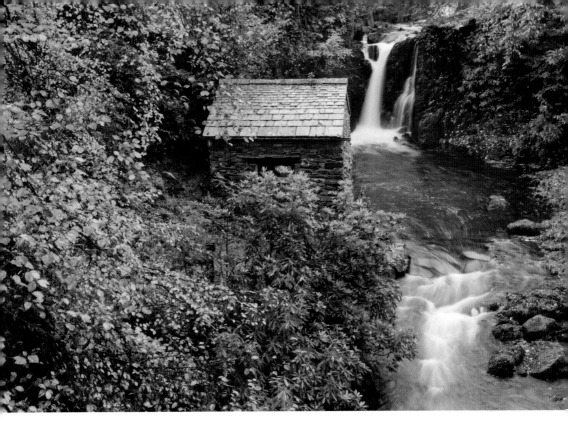

*Above*: Rydal Hall Grot.

*Below*: Galava Roman Fort, Ambleside.

of what should be expected, and this was linked to poor housing conditions for locals. New innovations were slow to reach the area and places such as the nearby Langdale Valley didn't get electricity until the 1960s.

Leaving Ambleside, the river joins forces with the Brathay and together they slide around the remains of the Roman fort and out into the longest lake in England.

## Leven

**Leven:** From the Celtic for 'smooth'
**Length:** 13 km (8 miles)
**Starts:** Windermere
**Ends:** Morecambe Bay

Far down at the southern end of Windermere the River Leven leaves the lake en route to the sea, and its departure point is flanked by Fell Foot Park on the eastern side and the Lakeside & Haverthwaite Railway on the western side.

Fell Foot Park is an extremely popular spot and is busy with visitors all year round, which makes perfect sense when you consider it offers beautiful gardens, family friendly lakeside access, changing facilities (including superb facilities for the disabled) plus plenty of benches, a lovely café and fresh, hot, pizzas straight from the oven. Who wouldn't want to visit? But the gardens and buildings we see today are all that remains of a once stunning estate.

The site was a natural fording point before tarmac roads and railways connected the region. In 1784 the farm that occupied the site was sold to a wealthy merchant from Leeds named Jeremiah Dixon. Mary, his wife, was the daughter of John Smeaton, who among many other things was responsible for the infamous third Eddystone Lighthouse. That lighthouse was dismantled and can be seen now in Plymouth, but if you don't fancy travelling that far then take a visit to Ulverston, on the estuary of the River Leven, and there you'll find the Sir John Barrow Monument (locally known as 'The Hoad' or 'The Pepperpot'), which is a scale replica of the same lighthouse.

The Hoad was designed by Andrew Trimen and built in 1850 from limestone quarried at nearby Birkrigg. It commemorates the life of explorer and founder of the Royal Geographic Society Sir John Barrow, who was born in the town and, although it has never operated as a lighthouse, it is a wonderful spot to visit with superb panoramic views stretching from Blackpool Tower to the Northern Fells on a clear day.

Back to Fell Foot. The Dixon family enlarged the farm to a beautiful villa overlooking the lake and landscaped the substantial gardens. In 1859 the villa and grounds were bought by Colonel George John Miller Ridehalgh. He updated the main villa, lighting it with locally generated coal gas, and he planted a diverse arboretum, elements of which we can still enjoy today.

Following his death, the estate was sold to Oswald Hedley, who promptly demolished the house and embarked on his own grand design. Sadly, he got no further than rebuilding the cellars when his wife died, causing him to abandon the estate. He remarried and in 1948, following his death, his widow gave the site to the National Trust in his memory and they have looked after it ever since.

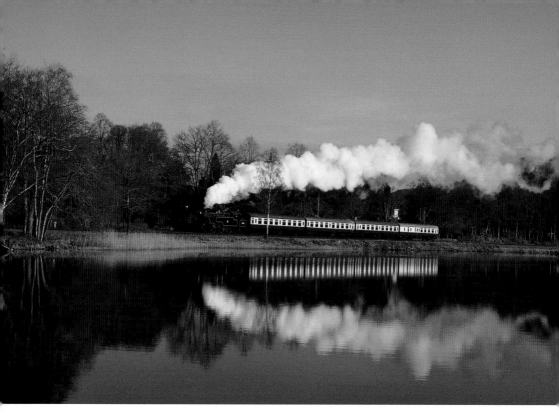

Lakeside and Haverthwaite Railway. (Image used with their kind permission)

The Lakeside and Haverthwaite Railway is all that remains of the steam lines that once dominated this region. During the 1850s and 1860s Furness Railway changed the area beyond recognition. Towns like Barrow exploded in population and, although originally created for freight, the railways soon became a mecca for visiting tourists, who would take a boat across the bay from Fleetwood to Ulverston then board a train through to Lakeside before embarking on a cruise along the lake.

This stretch of the line opened in 1869 and the golden era for visitors ran from 1872 through to 1938, when a combination of the Second World War and the boom of the car both contributed to its downfall. The whole line closed in 1965 but was thankfully saved from oblivion by a dedicated group who had to overcome numerous seemingly insurmountable obstacles before they could begin restoring the line. It reopened, to huge celebration, on 2 May 1973 and has been delighting visitors ever since.

A little exploration in the woods above the railway line will bring you to Finsthwaite Summer House Tower on Summer House Knott. The tower (formerly known as Pennington Lodge Tower) was built to commemorate the mariners from the Royal Navy, as well as those from the French, Spanish and Dutch navies who lost their lives in the Battle of the Nile in 1799. It has recently undergone an extensive restoration, including the addition of three striking slate memorials that detail the lives lost and contain dedications in all four languages.

Across the river from Haverthwaite is Low Wood, once the lowest bridged crossing point of the Leven and home to Low Wood Gunpowder Works. The site is a Scheduled

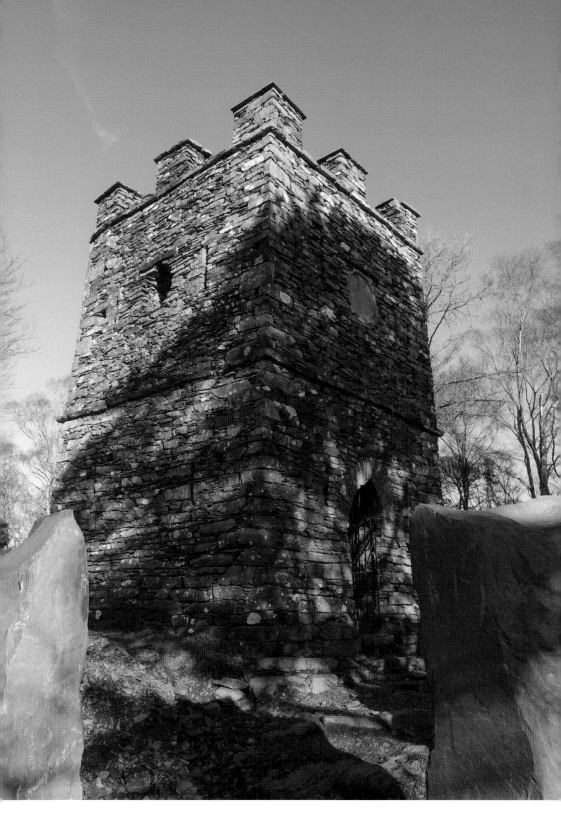

Finsthwaite Tower.

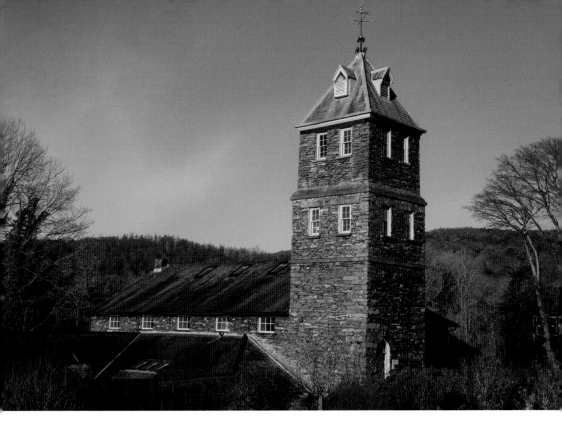

*Above*: Haverthwaite clock tower.

*Below*: Backbarrow Bridge.

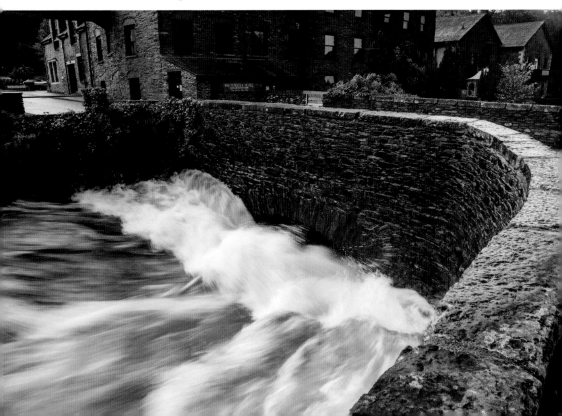

Monument and is the best-preserved gunpowder works in northern England. Originally the site of an iron works, gunpowder was produced on this site from 1799 until 1935, with the lovely clock tower being added in 1849. A walk through the adjacent woodland will offer good views of the original buildings, particularly during the winter months.

The original wheel pits for the gunpowder mill are now home to two large hydro-electric turbines. Although 'renewable energy' is much talked about these days, the hydropower here dates back to 1950, and the site underwent an extensive renovation in 2011 to improve efficiency and generate more power.

Looping out past Greenodd and Roudsea Wood, the Leven heads out to sea past Chapel Island, once an important stopping-off point for travellers caught out by tides when crossing the bay. The island takes its name from the chapel on the island, although the ruins that are there today are the remains of a folly from the early nineteenth century. Organised walks to the island take place throughout the summer months.

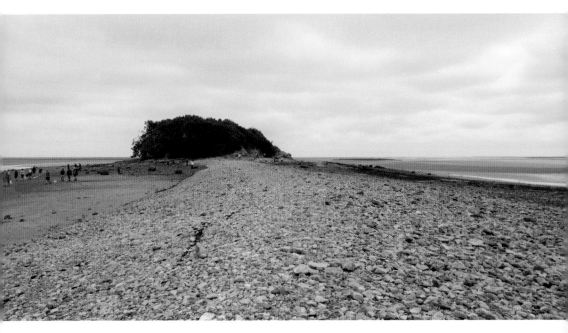

Chapel Island.

# 7
# River Esk

**Esk:** From the Celtic for 'plentiful fish'
**Length:** 25 km (15.5 miles)
**Starts:** Esk Hause
**Ends:** Irish Sea

The River Esk starts life in the shadow of England's highest mountain, Scafell Pike, and the footpath up along the river is a long but joyous one, with lots of opportunities to jump in for a dip during the summer months (or the winter ones, if you're feeling brave!).

In the upper reaches of the river the remoteness of the valley, coupled with a general lack of mobile phone signal, leave you feeling like you have stepped back in time. The Roman fort at Hardknott and the beautiful Lingcove Bridge are a reminder that people have been visiting this valley for many years, and it's easy to think that our ancestors left far more beautiful marks on the landscape than we do, but they actually changed the valley dramatically.

Waterfall below Scafell Pike.

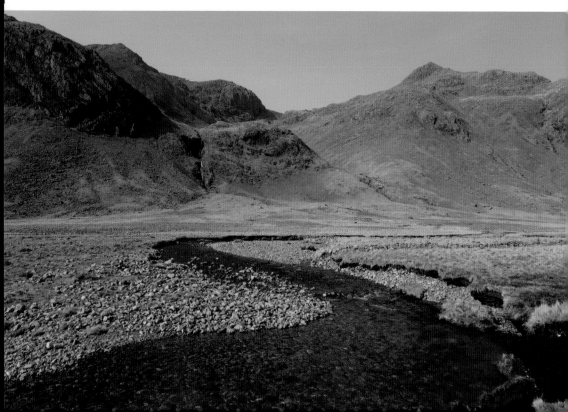

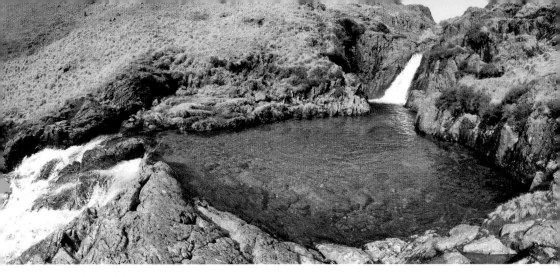

Pool on the River Esk.

The word 'unspoiled' is often used to describe places like this, but the reality is that man has had a dramatic impact on the area for many thousands of years. The fells and valleys around here were once dense with trees, which early Neolithic settlers cleared to enable them to farm the land, growing crops and rearing livestock. They also made good use of the rocks to create axe heads which they traded around the region.

Even a cursory glance at a map will reveal a multitude of cairns and ancient enclosures, and there are literally hundreds of burial mounds throughout the valley. One of the most remarkable ancient sites is the 'City of Barnscar' on the south side of the valley towards Devoke Water, where you'll find 400 cairns, hut circles and enclosures, as well as an avenue of paired stones – the remains of a prehistoric village.

The site is a Scheduled Monument and extensive archaeological surveys during the 1980s and 1990s have told us a lot about the people that lived here and how they farmed. Many of the cairns are 'clearance cairns' created using stones cleared from the land to improve farming conditions. In 1885 Lord Muncaster carried out surveys in the area and identified fragments of bone and pottery in some of the cairns, indicating they were used for burials.

Core samples taken from the bed of nearby Devoke Water have allowed us to track the pollen in the region and identify when the area was cleared of trees and when the grasslands took over. A major clearance took place during the Bronze Age, and another happened between AD 70 and 330, at which point cereal pollen appears, indicating that the area was used for crops. This ties in with the arrival of the Romans in the region when General Agricola built the first fort at Ravenglass at the mouth of the river. The fort at Hardknott was built over forty years later and the Romans remained in the valley for over 350 years.

Mining arrived in the valley in 1837 when James Read & Co. leased an area to the north of the Esk, and by 1841 there were seven iron ore mines in the area. The ore was moved down the valley to Ravenglass and then shipped to South Wales. The profitability of the mines varied over the years as the demand for iron ore waxed and waned. There may have been rich seams of haematite in the valley, but its inaccessibility made it expensive

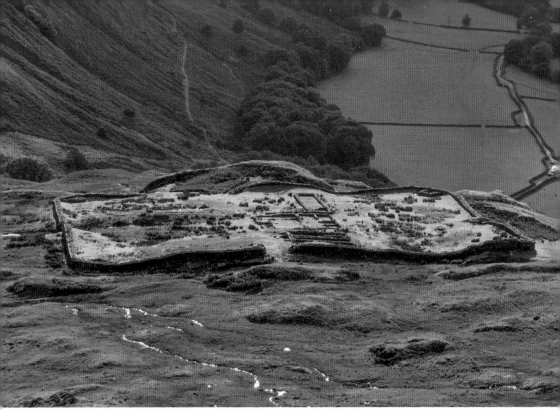

*Above*: Hardknott Roman Fort.

*Below*: Barnscar Common.

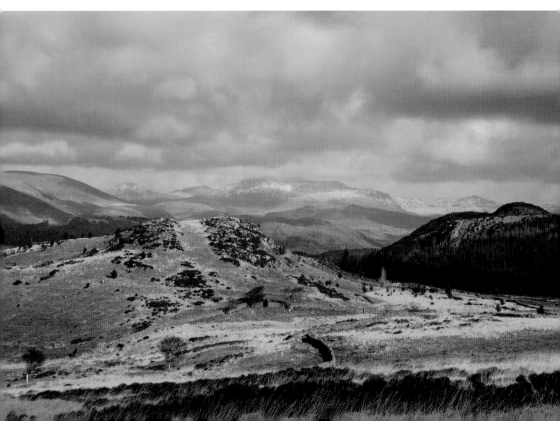

to extract and ship. The Franco-Prussian war in the early 1870s led to a sharp increase in price and the fact that the Cumbrian ore was the only one that was available in high enough quantities for early steel production meant that the region was, temporarily at least, one of the richest mining regions in the world.

The valley was also quarried extensively for granite, and the remains of the old quarries are dotted around the railway line. The quarry at Beckfoot proudly advertised that it produced 'the finest Cumbrian granite for roadstones, sets, kerbs and chippings'.

It was this extensive mining and quarrying that we have to thank for the beautiful railway that runs through the valley. Known locally as 'La'al Ratty', the Ravenglass and Eskdale Steam Railway was originally built in 1873 to transport the iron ore from the mines and down to Ravenglass, where it could be transferred onto the mainline coastal railway. When it opened its doors to passengers in 1876 it became the first public narrow-gauge railway in the country.

In 1913 the original railway closed due to a combined drop in both iron ore and passenger numbers, but in 1915 model makers and engineers W. J. Bassett-Lowke and R. Proctor-Mitchell began using the line to test their little locomotives. They gradually took up the original 3-foot-gauge track and replaced it with 15-inch gauge, following the track line as far as Beckfoot. From here they opted to take a less challenging curve around to Dalegarth, rather than follow the original route up to Boot, but the old route is still very easy to pick out on a map. From Dalegarth station there's a nice gentle circular walking route, if you fancy a leg stretcher before the train back. The route passes over Doctor

La'al Ratty.

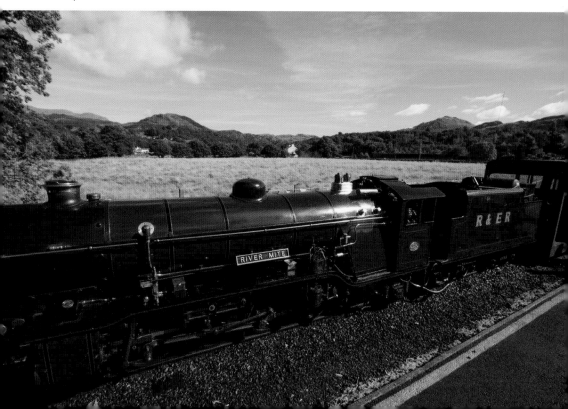

Bridge which is so called because local doctor Edward Tyson had it widened in 1734 in order to accommodate his carriage.

After various changes of ownership and an absolute cliffhanger of an auction in 1960, when the newly formed Ravenglass and Eskdale Preservation Society found last-minute support from a local landowner and a Midlands stockbroker, the railway underwent significant restoration, with new engines and visitor buildings being added. Work has been ongoing on the line ever since, with the new museum and visitors centre opening in 2018. It is now open all year round and is a wonderful way to explore the valley. You can take a round trip or hop on the train to Dalegarth and follow the Esk Way footpath all the way back down to Ravenglass for a well-earned pie and a pint in the Ratty Arms.

It would be remiss to write about the River Esk and not mention Muncaster Castle, a privately owned castle that can trace its origins back to the Romans, who once thrived in the region. It has remained in the same family since at least 1208, and possibly even earlier. The Roman influence is evident in the name; 'castra' comes from the Latin for 'fort' or 'encampment' and a Roman coin from AD 380 has been found on the site, as has a ring from the same period.

Stones from the original Roman building were used in the construction of the fourteenth-century pele tower and the site remained largely unchanged for several hundred years until the nineteenth century when the castle was dramatically extended and the gardens much improved. The oldest surviving feature in the garden is the terrace, which dates back to the 1780s, and the glorious variety of trees we see today are thanks to the Victorian craze for collecting exotic plants.

Barn owl.

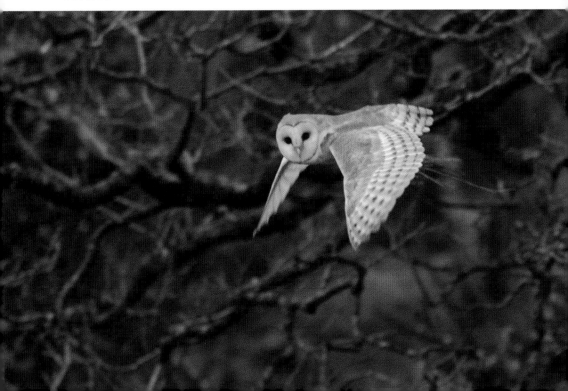

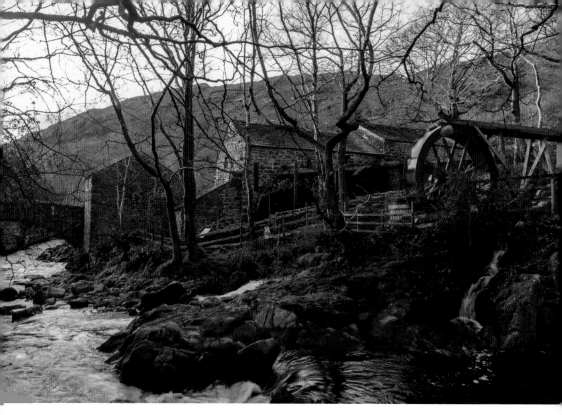

Eskdale Mill.

Whilst the gardens here are beautifully maintained with rare species being propagated and protected thanks to joint projects with places like Kew Gardens, this Victorian fixation with introducing non-native species has led to many ecological battles when they out-compete our native residents.

We've already met one 'luck' in this book (see the Luck of Edenhall in Chapter 1), and now we meet another, although there are fewer fairies associated with this one. The Luck of Muncaster is a fifteenth-century glass vessel, reputedly presented to Sir John Pennington by King Henry VI in 1461 as thanks for protection that the family had given him. He gave it with a prayer that 'the family should ever prosper, and never want a male heir, so long as they preserved it unbroken'.

A little further down the river is the less glamorous but in many ways equally as interesting Hall Waberthwaite. This manor was once held by the Waberthwaite family before it changed hands and eventually became part of the Muncaster estate in 1607. Tucked away in this tiny hamlet is the twelfth-century St John's Church and the remains of a beautifully carved Viking cross.

Once you have dodged their unique 'sheep protection system' at the main door, inside the church you'll find an interesting font that appears to have been carved from a single block of sandstone and has been possibly dated back to Norman times, and an austere but intriguing pulpit inscribed in Latin with the phrase 'Woe is me if I preach not the truth'.

The Viking cross can be found in the church grounds and is thought to date back to the late ninth or early tenth century. It is made from highly decorated sandstone and contains

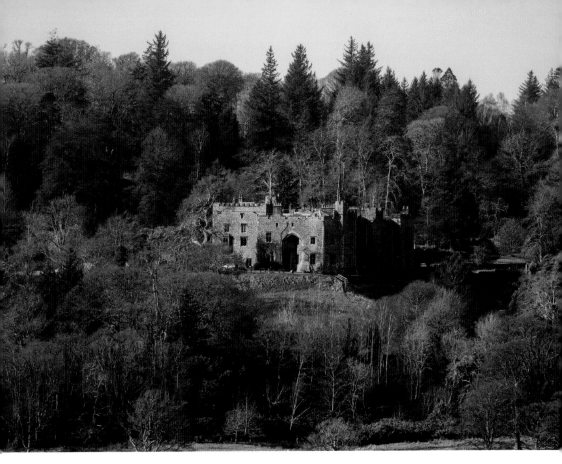

*Above*: Muncaster Castle.

*Below*: St John's Church.

several examples of birds and other animals, although they're not immediately obvious and you may need a few minutes to get your eye in.

At the mouth of the river lies Ravenglass to the north and Eskmeals Dunes to the south. Ravenglass is a tiny coastal town steeped in history, and that's hardly surprising as it sits at the mouths of three different rivers (the Esk, the Irt and the Mite). It was once home to a Roman fort and the remains of the Roman bathhouse are impressive and, rightly, draw many visitors throughout the year.

Eskmeals Dunes are rather more secluded and several centuries older than the remains in Ravenglass. The dune system was formed over 5,000 years ago as sand and silt built up around the shingle spit at the mouth of the Esk. The dunes are home to over 300 plant species and are recognised as a place of international importance thanks to its flora and fauna, such as the natterjack toad, rare butterflies and visiting birds.

The dunes are held together by native marram grass, with its tough roots and broad, stiff leaves binding the sand together. During the 1950s non-native sea buckthorn was planted to try and stabilise the dunes, but that is now being removed by Cumbria Wildlife Trust who lease the dunes from the Ministry of Defence.

Visiting the site has two main challenges, one man-made and one natural. The reserve is cut off from the mainland at high tide, so be sure to check the tide times beforehand and, as the site is owned by the MOD and is still used as an active gun range, also check the Cumbria Wildlife Trust website ahead of any visit, as they have details of when the reserve is fully open.

Roman bathhouse, Ravenglass.

# 8
# River Irthing

**Irthing:** Unclear – possibly 'a bear' or 'flowing spring'
**Length:** 46.9 km (29.2 miles)
**Starts:** Paddaburn Moor
**Ends:** River Eden

The River Irthing is despairingly referred to in most places as a 'tributary of the River Eden', but we decided to include it as, despite how it is referred to, the river flows through some of the most remote, beautiful, and historically interesting landscapes in the county; in fact, for a large section at the start – from Irthing head all the way to Gilsland – the course of the river actually defines the county boundary between Cumbria and Northumberland, as well as the edge of the Northumberland National Park.

It rises in Paddaburn Moor, in a place where you're unlikely to bump into many other people, although if you do go in search of the source it's advisable to take wellies. Or waders. Or even consider a wetsuit – oh, and a midge net in the summer. There are few places in the UK that are truly as wild and remote as this, with so few traces of human activity.

Crammel Linn Waterfall.

The river begins by flowing due east until it reaches Whitehill, where it turns hard left and flows south to Gavelock Hill, before turning again for the remainder of its course towards the south-west. Dotted along the banks are the remains of old shielings, a reminder of the small-scale way that the land around here was once worked.

As the river approaches Gilsland it tumbles over the dramatic Cimmel Linn waterfall, which is a spectacular sight, especially when the river is in spate, but is not always accessible. The route to the falls is along a permissive bridleway that has regularly been closed over recent years, partly due to Covid concerns, but also due to a lack of respect being shown by visitors who parked inconsiderately and left disturbing amounts of litter.

Just on the outskirts of the village are the Popping Stones, or maybe not. Having been a popular destination for visitors for many years and reputedly being where Sir Walter Scott proposed to Charlotte Scott in 1797, during a renovation to a nearby path in early 2021 the stones were damaged and moved by contractors who, presumably, had little idea of their historical significance. (By the time you read this they should, hopefully, have been fully restored!)

And so, to the village of Gilsland, a town right on the county boundary. At this point, when talking about boundary towns, writers often dig back deep into the historical archives to describe the impact of living on such a boundary, but we don't have to dig back very far with Gilsland to uncover an interesting impact of life in a border village.

In late 2020, when the Covid restrictions were in full force and the country was divided into tiers, Northumberland and Cumbria were, at times, in different tiers, meaning that half of the village was expected to follow one set of guidelines and not visit the other half of the village living under the other set of guidelines. Of the two village pubs, the one in the Northumberland side of the village was required by law to remain closed, whereas the other, on the Cumbrian side, would have been allowed to open, but the landlord took the decision to remain closed. Likewise, the café on the Cumbrian side could remain open, but people from the Northumberland side would not have been allowed in, so they took the decision to stick to serving takeaway food and drinks only during that time.

Popping Stone sign.

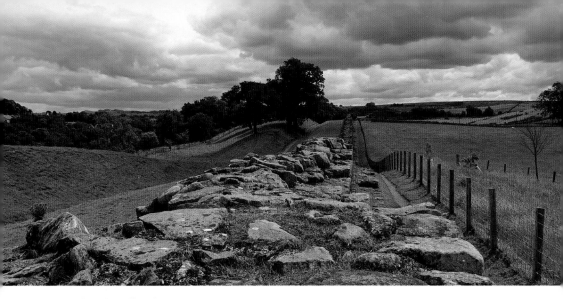

Hadrian's Wall path.

From Gilsland, the river continues its journey in the shadow of the remains of Hadrian's Wall and its many turrets and milecastles and would have provided a very handy fresh water supply for those stationed along its length. There's a lovely walk along the wall and you can't walk more than 10 yards without, almost literally, tripping over a Roman remain or artefact.

The maintained sites such as Birdoswald Fort are well worth a visit, and English Heritage offer a wide range of activities throughout the year for families to join in to get a feel for what life would have been like during Roman times. In many ways the area would have felt a lot less remote then than it does now – today, for example, we rely on mobile phone signals to keep us in touch with the world (and signal around here is patchy at best), but in those days the world came to you, with the wall being a hive of activity.

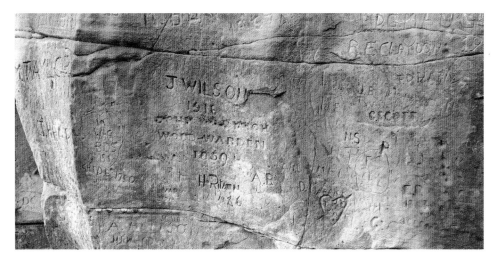

Old graffiti.

Along this stretch the wall and milecastles were originally built of turf and timber, and the turrets in between them were built of stone. At Birdoswald they first needed to clear the trees and drain a bog before building could begin, shortly after the wall itself was built in AD 122. Over 800 men were stationed here for the duration of the Roman occupation, and there are many magnificent, well-preserved sections of the wall along this stretch.

For a different view, take a detour from the main path and drop down through the old Roman quarry near Milecastle 51, where stone for the wall and fort originated, and if you go down as far as the river you can admire the beautiful gorge, where there are plenty of excellent places to perch and enjoy your lunch.

Back along the road to Gilsland you will find the remains of a bastle at Upper Denton. A bastle was a small, sturdy, farmhouse; less than 300 still survive and this one is a battered, but good, example with many original features still intact

Just before the river arrives at Lanercost Priory, look closely at a map and you will spot an 'Inscribed Rock' near Banks Foot. Now, it's not uncommon at all for Romans to inscribe rocks, but this one is possibly more interesting because it's probably fake. Or at least Collingwood thought so when he wrote about it in 1928. The inscription reads 'I BRVTVS DEC AL PET' and Collingwood makes the case that, having examined them closely, the weathering of the letters is not consistent with their purported age, the location for such a carving is all wrong (they are in a remote quarry face and not part of a roman built structure), and the language composition is inaccurate.

River Irthing Gorge.

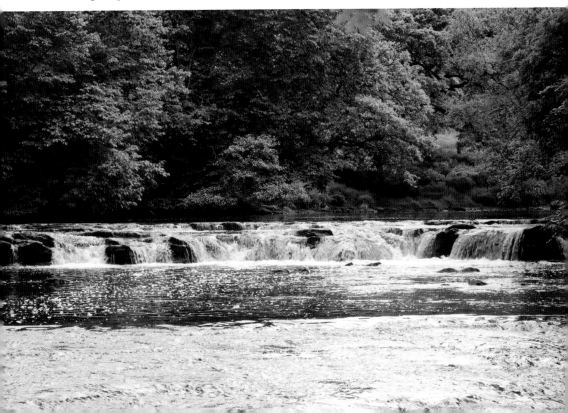

*Above*: Banks East Turret.

*Below*: Bastle at Upper Denton.

River Irthing.

His theory is that the inscription was carved to hoax a local historian in 1859, who had tried to demonstrate that there was a Roman station at Lanercost but had not been able to gather sufficient evidence. It's not thought that he did it himself, but rather that someone else did it to try and help his cause. The rock and carving are supposedly still there but are inaccessible.

Nearby is the beautifully elegant Lanercost bridge and the remains of the priory. The Old Bridge dates back to 1724 when it was built by four local masons and cost £493 (the equivalent of around £100,000 today), as a replacement for other bridges which had stood there before it. In an effort to preserve and protect this one, the words 'this is not safe for tractors' were carved into the stonework. In 1962, the nearby replacement bridge was built to handle twentieth-century traffic. The old bridge underwent an extensive refurbishment in 1998 and today it remains open to walk across and admire.

Lanercost Priory is a magnificent structure with sweeping sandstone columns and arches. The first section of the priory was completed in 1214, with many of the stones used having been taken from nearby Hadrian's Wall. The priory was dedicated to Mary Magdalene and her image can be seen carved into the western side of the church, with a canon kneeling next to her. There were around fifteen canons who lived at the priory and combined life as monks with looking after the local people. The site would have been far more than simply a church, and it's thought that there were animal enclosures, a brewery, tannery, fishponds, granary and hay store also on the site.

Being in a border location the priory has a colourful and, at times, violent history, as it changed hands between sides and took much damage from the various battles; treasures were raided and many precious artefacts were destroyed over the centuries. Over the winter of 1306/07 the priory was a temporary royal dwelling when King Edward I arrived in his pursuit of the Scots. The king was very unwell and that, as well as his large entourage, put a big strain on the priory. He eventually departed in March 1307 and continued his journey north, only to die at Burgh-by-Sands in July that year (see Chapter 1).

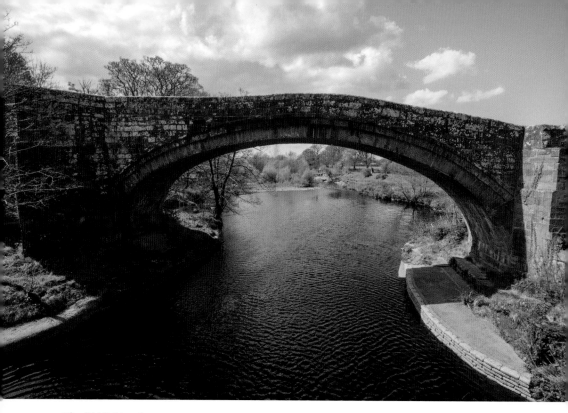

The Old Bridge, Lanercost.

The priory officially closed in March 1537, following the Dissolution of the Monasteries, but had, in reality, generated very little income for a very long time prior to that. Passing into private hands, the priory still struggled to be maintained and in 1930 the site was given to the Office of Works, the precursor of English Heritage, who care for the site today.

Hanging behind the alter in the priory is the Lanercost Dossal, a beautifully embroidered cloth designed by William Morris and embroidered by the ladies of the parish. The Dossal was commissioned in 1881 by George Howard, the 9th Earl of Carlisle, and was unveiled on Easter Sunday in 1887. George Howard's granddaughter was the artist Winifred Nicholson, and she lived at Bankshead, in the shadow of Hadrian's Wall, until her death in 1981. Her pictures are in the style of the Impressionists and are highly colourful, capturing the energy and beauty of the natural landscape around her.

The earls of Carlisle also owned the land that now makes up the market town of Brampton. In 1252 it was granted its market charter and became the hub for the north-east Cumberland area. During the seventeenth century grain was the main crop traded, with rye from nearby Gilsland being the most dominant crop.

It's a town that has waxed and waned in population. During the nineteenth century coal production came to the fore and provided most of the local employment, drawing people into the area, and the town was also home to breweries, tanneries and textile producers. As these businesses closed and moved elsewhere, the population fell, before being boosted again in the mid-twentieth century thanks to the building of RAF Spadeadam just to the north-east. Two new housing estates were built to accommodate the workers and, as the

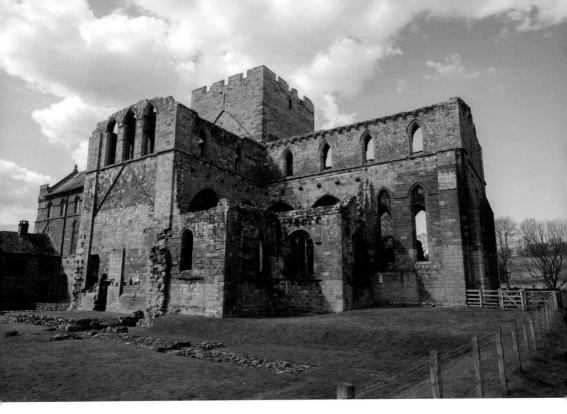

Lanercost Priory.

workers moved away once the site was completed, the town morphed again, this time into a commuter town for nearby Carlisle.

The rather lovely St Martin's Church in the town was built in 1878 to replace one built on the same site a century before, but prior to that the church had been right down on the riverbanks at what is now Old Church Farm. The original church was built into the corner of a Roman fort and the remains can still be seen, although you will need to collect the keys from the farm next door if you wish to visit.

As the River Irthing makes its final approach to the River Eden it passes Carlisle Lake District Airport. The site first came to life in 1941 as RAF Crosby-on-Eden, providing a much-needed landing strip that could accommodate bombers. Cumbria County Council bought the site in 1960, renaming it Carlisle Airport and, following a refurbishment, civilian flights to domestic destinations began in 1961.

Since then, the history has been fairly chequered, with new owners and various redevelopment plans meeting with varying degrees of success and numerous challenges. Commercial flights were due to re-launch in June 2018, but this was pushed back to July 2019, when the new terminal officially opened with flights to London Southend, Belfast City and Dublin airports. Sadly, the Covid crisis hit in March 2020 and the airport closed again on 1 April 2020 with, at the time of writing, no reopening dates planned.

# 9
# Rivers Liza and Ehen

## River Liza

**Liza:** From the Old Norse for 'shining river'
**Length:** 9.5 km (5.9 miles)
**Starts:** Windy Gap
**Ends:** Ennerdale Water

The source of the River Liza, high up between Great Gable and Green Gable, could not be more appropriately named. If you ever walk up there on a brisk, windy day, then you'll need to hang onto your hat, as well as something more substantial, as the wind whips through the gap at a mighty rate.

Great Gable is surely one of the most iconic of the Lake District fells, and easiest to spot when trying to orientate yourself on nearby peaks. In 2007, the view of Great Gable, from the far end of Wast Water, was voted as Britain's Best View, and it is a truly iconic peak that is also steeped in history.

On 8 June 1924, a war memorial was unveiled on its summit to commemorate the lives lost during the First World War and, as well as being a humbling memorial, its unveiling was also notable for its timing. At the same time as the memorial was being unveiled, George Mallory and Andrew 'Sandy' Irvine were last sighted on Everest before clouds obscured the view and created one of the biggest mysteries in mountaineering: 'Did they ever make it to the summit?'. Meanwhile, on Great Gable, the war memorial was being unveiled by writer, poet, mountaineer, and George Mallory's mentor Geoffrey Winthrop Young who, obviously, had no idea about how events were unfolding half a world away.

It was a typical English summer's day, with rain blowing in horizontally, as those assembled dedicated the plaque and handed over the title deeds to 3,000 acres of surrounding land to the National Trust to protect the land for future generations. Each year there is a service of remembrance on top of Great Gable that attracts several hundred people, keen to pay their respects, whatever the weather.

The mountain has always been a magnet for climbers, especially the notorious Napes Needle in front of the south-west face. This iconic monolith was first conquered in July 1886 by Walter Parry Haskett-Smith who, reputedly, performed a handstand when he reached the summit. Haskett-Smith came from a wealthy but somewhat colourful family, with one sister being placed into a 'mental institution' at the age of just thirteen and never being heard of again and a brother, who was homosexual (a scandal at that time), who 'accidentally' shot himself in the head with a 12-bore shotgun whilst cleaning it shortly after being involved in a major scandal. Then there was the brother's friend who drowned in suspicious circumstances and was suspected of being Jack the Ripper...

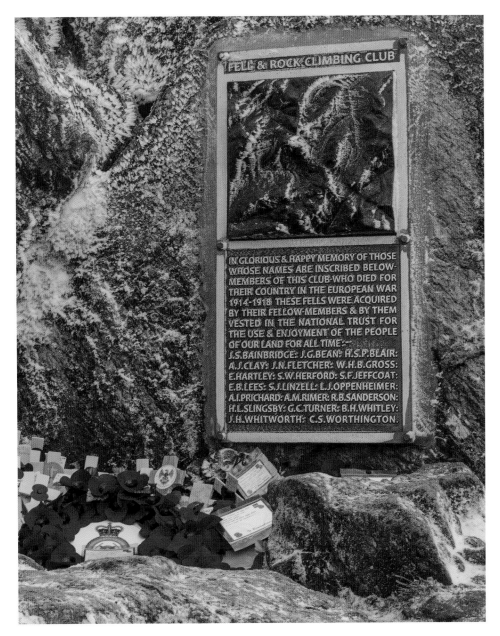

FELL & ROCK CLIMBING CLUB

IN GLORIOUS & HAPPY MEMORY OF THOSE
WHOSE NAMES ARE INSCRIBED BELOW.
MEMBERS OF THIS CLUB WHO DIED FOR
THEIR COUNTRY IN THE EUROPEAN WAR
1914-1918 THESE FELLS WERE ACQUIRED
BY THEIR FELLOW MEMBERS & BY THEM
VESTED IN THE NATIONAL TRUST FOR
THE USE & ENJOYMENT OF THE PEOPLE
OF OUR LAND FOR ALL TIME:—
J.S.BAINBRIDGE: J.G.BEAN: H.S.P.BLAIR:
A.J.CLAY: J.N.FLETCHER: W.H.B.GROSS:
E.HARTLEY: S.W.HERFORD: S.F.JEFFCOAT:
E.B.LEES: S.J.LINZELL: L.J.OPPENHEIMER:
A.I.PRICHARD: A.M.RIMER: R.B.SANDERSON:
H.L.SLINGSBY: G.C.TURNER: B.H.WHITLEY:
J.H.WHITWORTH: C.S.WORTHINGTON.

Great Gable war memorial.

Haskett-Smith's ascent of Napes Needle was a revolutionary moment in the world of rock climbing, although he really didn't see it as such and left a note in the Wasdale Hotel climbers' books that included, 'The pinnacle may be recognised (till the next gale of wind) by a handkerchief tied to the top.'

Following the footpath down from Windy Gap and along the River Liza, it's not long before you find Black Sail Hut, one of the oldest hostels in the UK. The hut started life as a

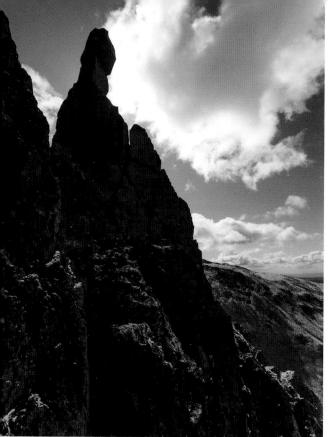

*Left*: Napes Needle.

*Below*: Black Sail Hut.

simple shepherd's bothy, providing shelter to those tending their flocks in the wilds of the fells. As farming methods changed, it fell out of use and opened as a hostel in 1933, when the accommodation was a lot more basic than you will find today. Beds were nothing more than a piece of canvas stretched between a metal frame, but it offered the thing that still draws people to it today – a chance to escape the rat race and find peace in the mountains (unless you happen to be sharing the hut with a loud snorer!)

Remote as the valley is, it has drawn visitors for many millennia and boasts one of the finest collections of Bronze Age and medieval archaeology in the country. Over 500 individual archaeological sites have been discovered in the valley. Between March 2016 and September 2017, the Forestry Commission (who now own much of the land in the area) commissioned a series of excavations to two clearance cairns that were being threatened with destruction due to a change in the course of the river.

The excavations have provided evidence that the valley was a hive of activity from the early Bronze Age (and possibly earlier), and that the cairns were built much more systematically than had been originally thought. It also demonstrated later Iron Age activity, during which time the cairns were expanded. Sadly, at the current rate of erosion, it is feared that these cairns could be lost before 2030.

Whilst it's tempting to say that we should step in to prevent that, the Ennerdale Valley is home to one of the UK's largest 'rewilding' projects, which has been in place since 2003. The aim of the Wild Ennerdale Partnership is to allow the landscape to evolve naturally, with little human intervention.

Ennerdale Valley.

The collaboration is between the National Trust, the Forestry Commission and United Utilities (the main landowners in the valley), and Natural England, and they are taking a 'one valley' approach to manage the region holistically, reducing barriers between the organisations and recognising that the whole valley is comprised of dynamic systems which cannot be effectively managed in isolation. Some of their achievements to date include:

- Planting over 40,000 native tree species
- Moving from intensive sheep to extensive cattle grazing across much of the valley
- Creating new heathland and restoring valley bottom bogs
- Reintroducing rare butterflies
- Restoring the original watercourse
- Boosting the populations of rare Arctic charr and red squirrels

One thing which may strike you as you wander along this stretch of the river is the forest and nature of the trees. The valley had once been an important site for Herdwick breeding, but in 1920 the Forestry Commission bought the site and planted the conifers, meaning the sheep had to be relocated to the surrounding valleys. Today sixteen farms remain, grazing livestock away from the forest.

Ennerdale Water was originally a natural, shallow, glacial lake before being converted to a reservoir to serve the people of West Cumbria, although that is something that has always been dogged in controversy and is about to change.

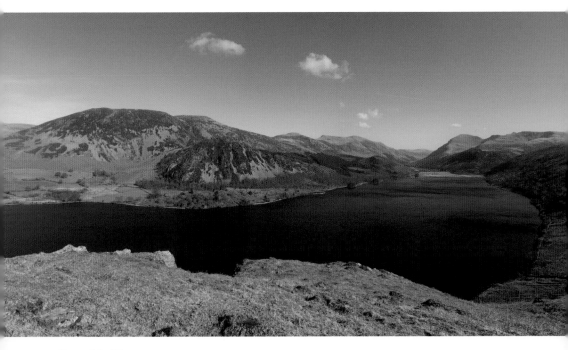

Ennerdale Water.

From April 2022 Ennerdale Water ceased to operate as a reservoir in a move designed to preserve and protect the valley. Instead, water will be supplied via a 62-mile pipeline from Thirlmere Reservoir in a project that has taken eight years from start to finish and, if you visited North Cumbria during that period, you will no doubt have seen the immense building works taking place. It has been an epic undertaking which should have a positive impact on the whole region.

## River Ehen
**Ehen:** From the Old Welsh for 'cold river'
**Length:** 24.1 km (15 miles)
**Starts:** Ennerdale Water
**Ends:** Irish Sea

The River Ehen winds its way out of Ennerdale Water, over the shallow weir at the western end and out through the village of Ennerdale Bridge. Although only small, and in a rather remote valley, the village can be a hive of activity during the summer months as Wainwright's 'Coast to Coast' walking route passes through it, bringing welcome trade to the local shop and pubs.

The River Ehen could be described as a pearl in Cumbria's crown for many different reasons, not least of which is because it is home to the largest viable population of freshwater mussels in England. Adult mussels can live for over 100 years but, sadly, the population is in decline because juvenile mussels are not being produced at the same rate

Sweeping bends in the River Ehen.

that the adults are dying off, so urgent action is required, which is why the river is part of the Pearls in Peril (PIP) project.

PIP is a UK-wide project with twenty-two partners working together to protect and restore places that are a natural home to freshwater mussels, and salmon and trout, which the mussels rely on as part of their reproductive cycle. The project is focused on the stretch of the Ehen that runs from Ennerdale Bridge to Cleator Moor and, although it is a project that still has far to go, it has delivered some encouraging results so far with initiatives that work in harmony with the landscape. You can find out more at westcumrbiariverstrust.org.

Further to the west the river sweeps around the much-overlooked town of Egremont. The town can trace its origins back to the Bronze Age, but really came to prominence in the tenth century when the invading Danes built a fort on the site where the castle stands today. In the twelfth century the land came into the ownership of William de Meschines who decided to make it the capital of Copeland (or Kaupland – literally 'bought land') and built the castle.

A series of mishaps, illnesses, female children, and wars gave rise to the legend that the castle was somehow cursed and that no male heir would ever inherit the castle due to the behaviour of their forefathers. The castle is also home to the legend of the Horn of Egremont, a story popularised by William Wordsworth in his poem 'The Horn of Egremont Castle', which tells a tale of treachery between brothers and a horn that only heirs to the castle could blow.

Egremont Castle.

The town is also home to the annual crab fair, which has nothing to with seaside crustaceans and everything to do with crab apples. The fair began back in medieval times when, after the harvest, the locals would gather to make their produce payments to the lords of the manor. A royal charter by Henry III in 1267 granted the town a weekly market and an annual fair that could take place on 7, 8 and 9 September every year. Over the years the dates changed, largely because the calendars in the UK changed on 3 September 1752, pushing everything back by eleven days and meaning that 3 September became 14 September, so the fair moved later in the month. Over the centuries activities at the fair have taken many forms, from cock fighting to competitive pipe smoking and, of course, what local fair would be complete without gurning?

These days the fair is held over the third weekend in September when the town comes alive with local food stalls, live music, and dancing, and the streets are filled with people all very keen to demonstrate their selfless support for the local inns and breweries.

The Horn of Egremont legend.

Braystone's Tower.

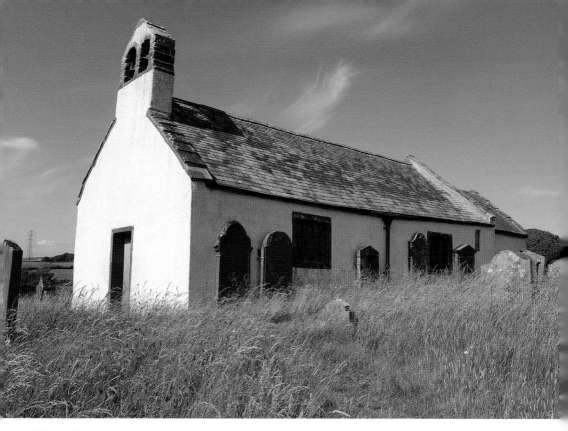

Old St Bridget's Church.

If you're looking for a curious but interestingly out-of-the-way place to visit, then you could do a lot worse than Beckermet (literally, 'where becks meet'), a mile or so downriver. There you will find Braystone's Tower built to mark the diamond jubilee of Queen Victoria and the old 'low' church of St Bridget – a tiny thirteenth-century church built on the site of a seventh-century monastery. It is a simple, but strikingly pretty, little church and has the remains of two ancient crosses in the graveyard.

As it ends its journey the River Ehen flows from the ancient to the modern in just a few hundred yards, leaving the seventh century behind and flowing along the perimeter of the Sellafield site, before finally escaping out into the Irish Sea.

# 10
# River Caldew

**Caldew:** From the Old Anglican for 'cold' or 'swift' river
**Length:** 43.4 km (27 miles)
**Starts:** Skiddaw
**Ends:** River Eden

The River Caldew is the only river in this book which is relatively easy to walk the entire length of, and if you did so you would take a wonderful journey through some of Cumbria's lesser-visited landscapes and discover some intriguing moments in the history of the county. It's also the only river that disappears along its own course, only to reappear again further downstream, but more of that later...

The Caldew springs into life beneath the summits of Sale Fell and Skiddaw, and drops down past Skiddaw House, the highest and one of the most remote hostels in Britain. Originally built in 1892 by the Earl of Egremont as a keeper's lodge, it started life as two distinct dwellings, with one house being for the gamekeeper's family and the other one for the local shepherd's family.

In 1857 the estate was broken up and Skiddaw House was sold to a local farmer. Over the years it has been a shooter's cabin, a school outdoor pursuit centre, and a bothy. Following an extensive refurbishment, it opened as a hostel in 1987 and, for the most part, has remained one ever since. At the time of writing it is on the market, and has operated as an independent hostel affiliated to the YHA for many years. Staying here means properly stepping back in time, as there is no mobile phone signal, so guests sit

Source of the Caldew.

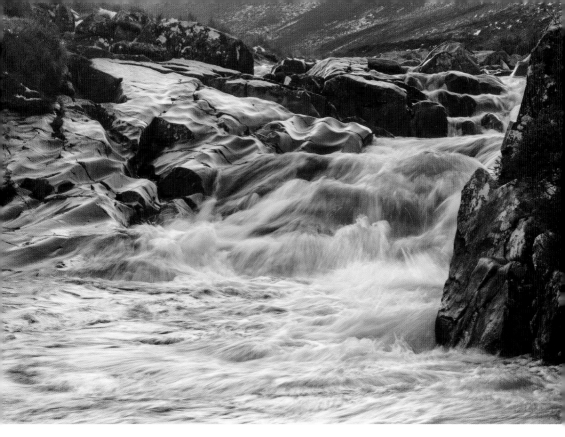

River Caldew.

around talking, drinking, laughing, eating communal meals, and swapping stories about hiking adventures and mishaps.

The views around the hostel are unspoilt, but that wasn't always the plan; back in the 1950s there was a proposal to build a dam and turn this beautiful, but narrow, valley into a reservoir. Thankfully they never came to fruition, and today there is a lovely walk from Mosedale, along the Cumbria Way, all the way up to the source of the river.

The area is also home to Carrock mine, or at least the remains of it. The mine's claim to fame is that it was the only economically viable tungsten mine in the UK outside of Cornwall.

While we're on the subject, the Cumbria Way was proposed by the Cumbrian contingent of the Ramblers Association during the 1970s. They put the route together and worked with the park authority and county council to make sure it was properly signposted and maintained. The full route stretches for 112 km (70 miles), starting in Ulverston and running all the way to Carlisle, following large sections of the River Caldew on the run into Carlisle.

In Mosedale, where the river emerges from the fells and swings north, there is an old Quaker Meeting House which began holding meetings in 1702. The site has strong connections with the founder of the Quaker movement, George Fox, who visited the area in 1653. By the late seventeenth century, the number of Quakers in the region was increasing and the house was reorganised to accommodate the meetings.

*Above*: Carrock Mine.

*Left*: Waymarker.

Between 1865 and 1973 meeting numbers fluctuated and the house, at different points in time, was used as a reading room for men working at nearby Carrock mine, a Methodist chapel, and a Church of England chapel of ease, when water, electricity and sanitation was added. Today the Quaker meetings have returned, and the hall is in use throughout the year.

This area is now known as Mungrisdale, but was originally four separate townships: Bowscale, Berrier & Murrah, Mosedale, and Mungrisdale. In 1934 they were all amalgamated into the parish of Mungrisdale, but the old township stones can still be spotted around local verges. On the original series of OS maps seventeen stones were marked and, thanks to a project in 2012, thirteen have now been found and restored, with two excellent examples next to Mosedale Bridge.

Along this stretch the River Caldew has benefited from a 'remeandering' project, which is returning the river to its natural course and removes artificially straightened channels and banks. The process reduces flooding further downstream (in this case in Carlisle, which suffered very badly following the storms in 2005 and 2015) and improves wildlife by slowing the flow around bends and allowing fish and insects to spawn.

Bowscale township stone.

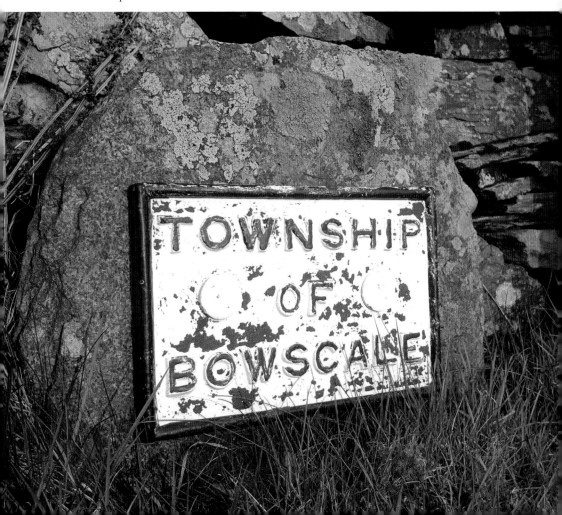

Along the next stretch the river performs a disappearing act, and that's thanks to the magic of the limestone bedrock. At a crook in the river just to the south of the village of Millhouse, much the river (all of it during summer months) vanishes underground down a large sinkhole in the riverbed. From here the river travels underground for several miles, with most of it reappearing 5 miles away near Sebergham and the rest popping out a whopping 9 miles away near Dalston. Sinkholes and disappearing rivers are not unusual on limestone bedrock, as anyone who was visited Malham Cove can attest, but the fact that this one appears to have opened up, or at least been substantially enlarged, over recent years, has attracted a good degree of local attention.

Along the dry stretch you'll find the pretty little village of Hesket Newmarket – Heskett Bridge to the north-east of the village is a pretty spot, but perhaps not one you should visit with a game of Pooh Sticks in mind. The main village is a collection of rather lovely eighteenth-century homes and it was once granted a market charter, but the idea never really caught on, leaving a pretty and largely unspoilt village centre.

Hesket Hall was built on the site of an earlier farmhouse during the late eighteenth century, and it is most notable architecturally for its unusual collection of sharp and unusual angles which have been described as 'a curious structure with twelve angles, so contrived that the shadows show the hours of the day'.

The village is also home to a co-operatively owned pub and brewery and everyone in the co-operative contributes in some way. The brewery was originally started by Jim and Liz Fearnley in 1988, and when Jim retired ten years later the locals got together to buy both the pub and the brewery to keep them going. Today the brewery produces a range of six 'core' beers, as well as a wide range of special brews for different occasions. The pub is also said to be a favourite with King Charles III who, apparently, has been known to visit when he's in the area.

Just to the north of Hesket Newmarket, the Caldew is joined by the Caldbeck and together both rivers now head east and then north towards Carlisle. Although not directly on the Caldew, the village of Caldbeck is worth a mention because it is such a beautiful and interesting spot. In the space of a small circular walk you'll pass the remains of an old mill (more on mills later), and the atmospheric Howk waterfall and the grave of local hunting legend John Peel.

Much renowned as a hunter, John Peel is best known for being immortalised in a song written by him and a friend during a drunken night in Caldbeck in 1828: 'Did ye ken John Peel...'. Originally written in the Cumbrian dialect and sung around the pubs in the area, it was fourteen years after his death that William Metcalf, a conductor, composer and lay clerk of Carlisle Cathedral, rewrote it, 'translating' it into English, opening the song up to a wider audience and cementing John Peel into the legends of the county.

On top of all that, there's Priests Mill, a haven of finds produced by small, local, businesses, and, of course, the Watermill Cafe, where you can eat cake and admire the wonderful historic building.

Writing a book like this, it would have been very easy to fill every page with pictures and descriptions of the many beautiful bridges in the county. Instead, we have restricted ourselves to only those truly worth of merit; one such bridge is Bell Bridge. The 'old' bridge was built in 1772 to replace the original wooden one that had been destroyed in a

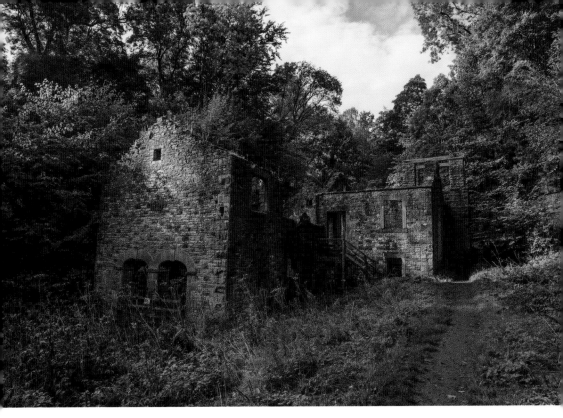

*Above*: Mary Bobbin Mill, Caldbeck.

*Below*: Priests Mill, Caldbeck.

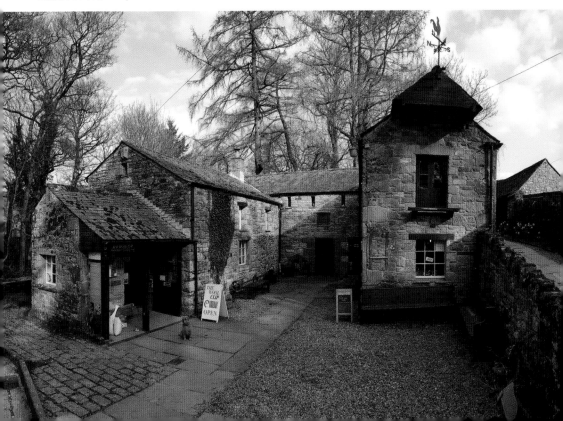

flood and, because it was commissioned by the nearby Bell family, it was known as Bell Bridge. Sadly, this elegantly arched Grade II listed bridge was itself destroyed by a flood, this time Storm Desmond in 2015. It took two years to build a replacement and, although clearly modern in design, the new bridge harks back to the elegant lines of the original bridge and was very much welcomed by local communities.

A few more twists and turns of the river will bring you to Rose Castle, which has been home to the Bishop of Carlisle (on and off) since 1230, although the house has been through several incarnations during that time. The original castle is likely to have been built from wood, with a stone castle first appearing during the fourteenth century. Despite an agreement to spare the caste, it was raised to the ground by Robert Bruce shortly after, before being rebuilt in 1355, then destroyed by fire, then rebuilt again.

During the fifteenth century, huge defensive walls were built around the castle, with a moat added for extra security. It was battled over during the War of the Roses and, following a siege in 1648, a garrison of Roundheads remained there, but when the Royalist troops advanced the Roundheads retreated, burning the castle to the ground as they left. In 1660 the Bishop of Carlisle took up residence again and, although the castle has avoided being completely destroyed again during that time, many of the early bishops added and subtracted bits to the castle, leaving us with the impressive structure we see today. It was requisitioned by the RAF during the Second World War, with the bishop finally returning in 1955, and it has remained at peace since then.

Bell Bridge.

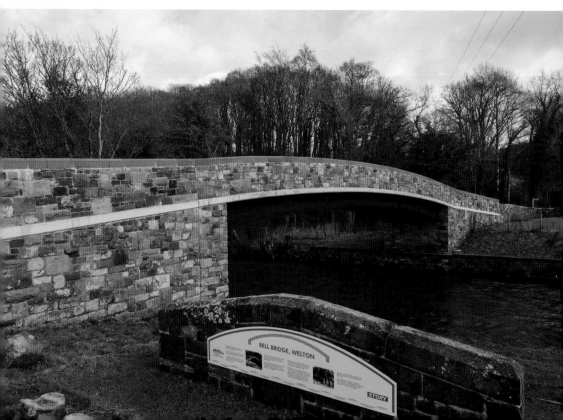

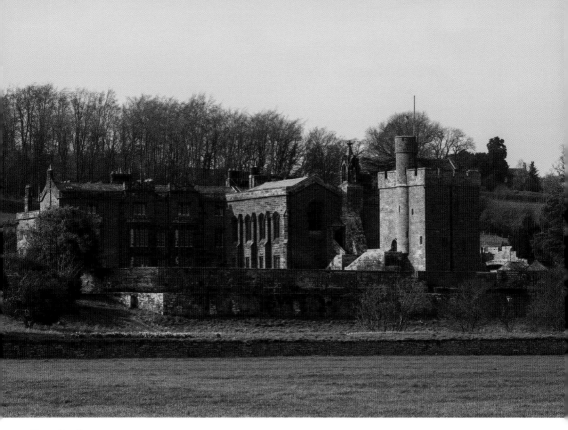

Rose Castle.

Sweeping round a large bend and past Hawkesdale Hall, a late seventeenth-century Grade II* listed building that was built and owned by the brother of the Bishop of Carlisle, the Caldew arrives at Dalston. Now, if you've followed the route of the river on a map, you will have noticed how many mills are marked along its length. Rivers are generally viewed as a place for nature, but fresh water has always been an essential requirement to support human habitation, so for most rivers there has been an ongoing battle between the demands of the human population and the requirements of the flora and fauna that rely upon it.

There have also been plenty of battles between humans over who has what rights to the water, and these battles have a tendency to get ugly, especially where business is concerned. And, almost unbelievably, that's what happened along this seemingly tranquil stretch of the Caldew. In the early nineteenth century Samuel Taylor Coleridge passed through Dalston and described it as 'a plain of ugliest desolation, flooded with stones and sand by winter torrents'.

Harsh words, but during this time the area was choc full of mills along the length of the river, all needing/demanding water in order to function. One of the buildings that so offended Coleridge was a cotton mill belonging to Daniel Hebson, who had reached a financial agreement with the bishop for use of the water coming from the corn and forge mill, owned by the church. This must have proved a huge success because within a few years Mr Hebson had built three more mills along the river.

An 1836 map of the factories, mill races, and weirs around Buckabank show a complex arrangement of interdependencies. This was not conceived as one seamless supply, instead it began as one arrangement, with new arrangements being bolted on at later dates as the need arose. Each new addition was covered by an agreement not to impede access to waterpower for any existing user – naturally, this all fell apart pretty quickly. Protracted legal battles ensued, and at one point the flow of the river was diverted by one of the aggrieved parties, leaving all the mill races downstream without water and, therefore, without power. A settlement was finally agreed, but, as is always the case with these things, the only true winners financially were the lawyers.

One place that escaped the chaos of the court battles was Cardewlees Windmill. Prior to the repeal of the Corn Laws passing in 1846 (laws put into place following as a response to the Napoleonic Wars which kept the price of corn artificially high to support local farmers and block cheaper imports from Europe), the parish was known as the 'Corn Parish' for its voluminous production of corn, and windmills would have been a common sight around the county. Today only seven remain and most are in private ownership.

From Dalston the Caldew sweeps into Carlisle, passing alongside the castle before joining the River Eden in the centre of the city, and continuing on to the Solway.

Carlisle Castle.